Sampler Book 2, Ontario in Colour Photos, Saving Our History One Photo at a Time

Photography by Barbara Raué

Series Name: Cruising Ontario

Sampling from several towns

Each photo I take that precedes a demolition, or a natural disaster such as a tornado or a fire, is meeting this aim of mine of Saving Our History One Photo at a Time. There are more than 100 towns already photographed which you can visit without moving from your comfortable chair in your living room. Dream about what it was like in those by-gone days. Dream about what it was like to live in a mansion like one of these. Where would you like to travel to next?

Cover: 1 Wellington Street, St. Thomas

Table of Contents

Hagersville, Ontario – My Top 6 Picks

Caledonia, Ontario – My Top 6 Picks

Simcoe, Ontario – My Top 6 Picks

Galt, Ontario – My Top 6 Picks

Hespeler, Ontario – My Top 5 Picks

Preston, Ontario – My Top 6 Picks

Kitchener, Ontario – My Top 6 Picks

St. Thomas, Ontario – My Top 5 Picks

Stratford, Ontario – My Top 6 Picks

Hanover, Ontario – My Top 5 Picks

New Hamburg, Ontario – My Top 8 Picks

Waterdown, Ontario – My Top 7 Picks

Stoney Creek, Ontario – My Top 6 Picks

Seaforth, Ontario – My Top 6 Picks

Aberfoyle and Morriston, Ontario – Top 6 Picks

Eden Mills, Eramosa and Everton, Ontario – My Top Picks

Fergus, Ontario – My Top 7 Picks

Hagersville, Ontario – My Top 6 Picks

Hagersville, a community in Haldimand County, is located about 45 kilometers southwest of Hamilton, Ontario, and 15 kilometers southwest of Caledonia.

In 1852, Charles Hager built a frame hotel at the corner of the Plank Road and Indian Line. It was called The Junction Hotel and later The Lawson Hotel after a change in ownership. Hagersville's first post office was in this hotel. With the construction of the Plank Road, a small village popped up in 1855 when Charles and David Hager bought most of the land in the center of the area. David Almas owned the land on the east side of the road, while John Porter owned the land in the west end. Joseph Seymour suggested the community be called Hagersville to honor the Hager brothers.

The building of the Canada Southern Railroad in 1870, and of the Hamilton and Lake Erie Railway three years later helped to make Hagersville a prosperous village.

Hagersville gained notoriety in 1990 with a huge uncontrolled tire fire which spewed toxic smoke into the atmosphere for seventeen days. The fire actually occurred in Townsend, a neighboring community, but media labeled it as Hagersville due to Townsend's relatively unknown status in the area.

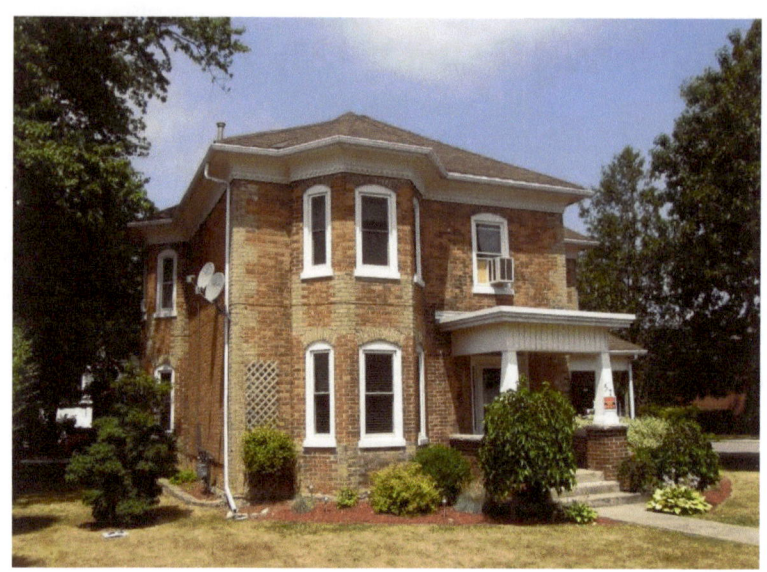

Italianate style, dichromatic brickwork, two-storey bay window

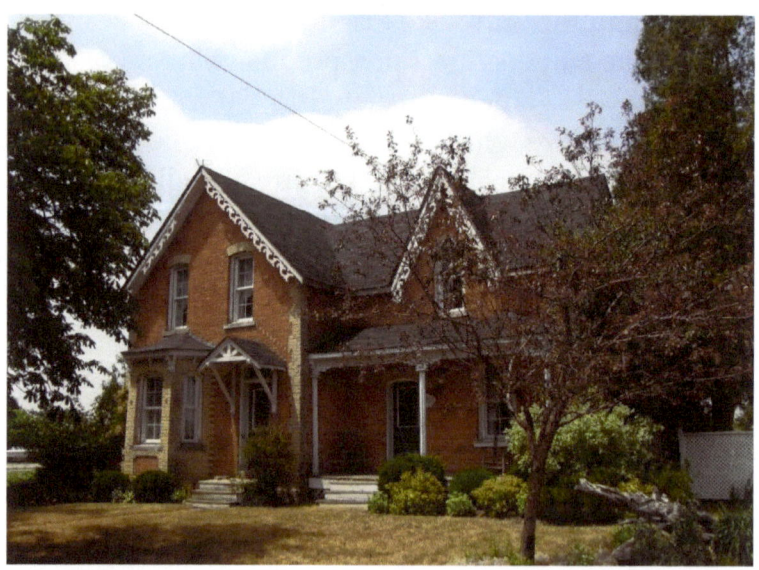

Gothic Revival style – verge board trim, bay window

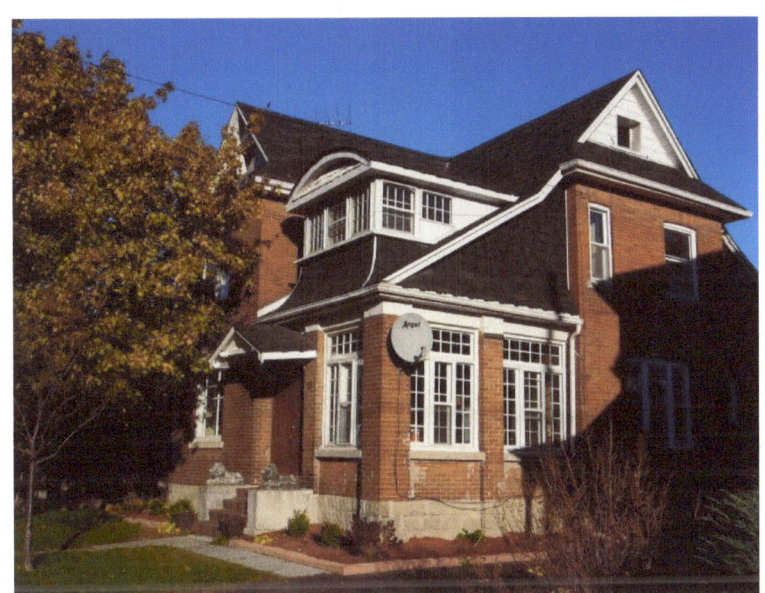

Queen Anne style

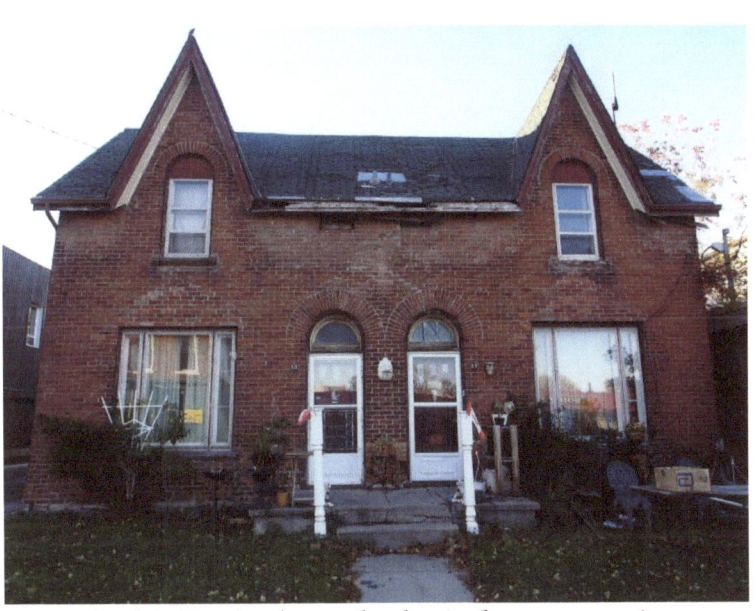

Gothic Revival – arched window voussoirs
#15 and #17 – duplex

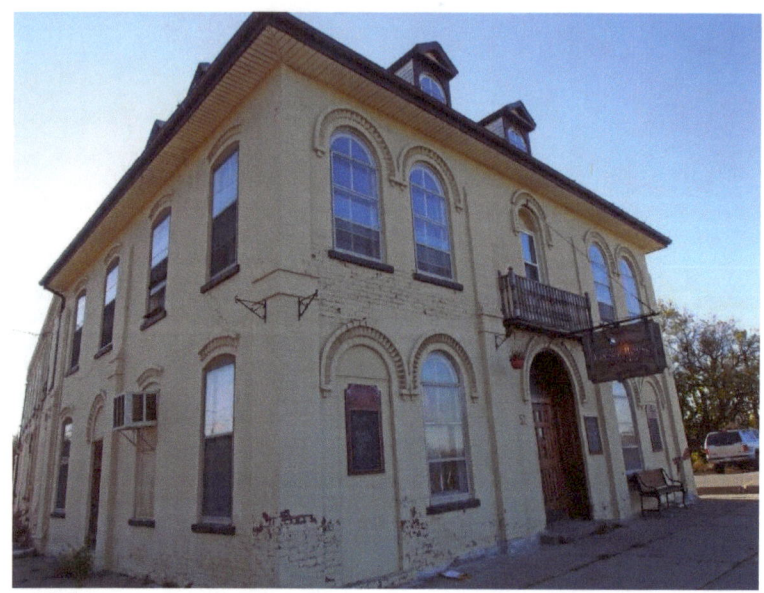

The Old Lawson House Eatery and Pub – dormers, Italianate style, arched window voussoirs

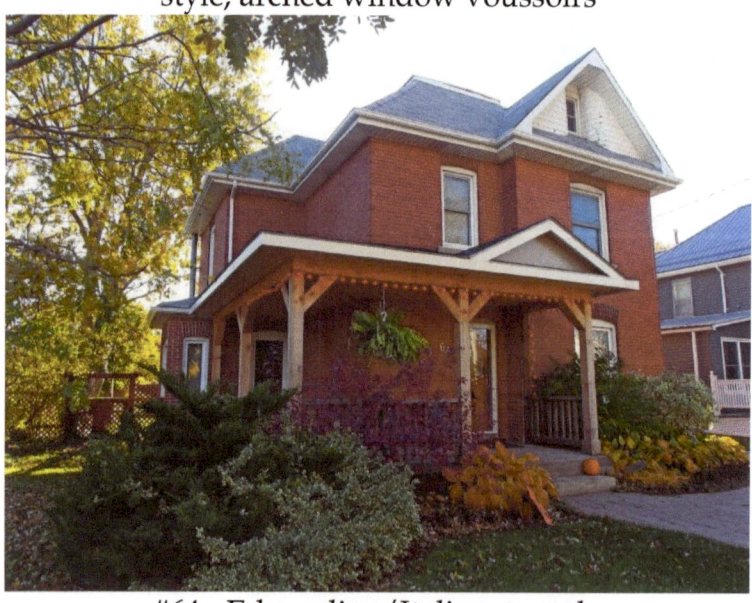

#64 - Edwardian/Italianate style

Caledonia, Ontario – My Top 6 Picks

Caledonia is a small riverside community located on the Grand River in Haldimand County. It is located at the intersection of Highway 6 and Highway 54 (within the town, these streets are called Argyle Street and Caithness Street respectively). On Highway 6, the town is 10 kilometers south of Hamilton and 10 kilometers north of Hagersville. On Highway 54, the town is 15 kilometers east of Brantford and 10 kilometers west of Cayuga.

The Grand River flows 293 kilometres from the Dundalk Highlands to Lake Erie and is the largest river in southern Ontario. The river winds its way through marshes, woods, farmsteads, and communities. Rainbow trout use this river in their migration.

Caledonia was once a small strip of land between Seneca and Oneida villages. The Grand River traveled through Caledonia dividing it into two sides, North and South. In 1834, Ranald McKinnon was hired to build a dam in Seneca and a dam in Caledonia. Completed in 1840, the dams made water power available. The dam at Caledonia was constructed as part of a series of dams, locks and canals to facilitate navigation of the Grand River from Lake Erie to Brantford. Mills were built throughout Seneca village, and five mills were built in Caledonia by 1850. Commercial navigation ceased by 1879, but the dam continued to serve the local mills and provided a recreation opportunity. The present dam was built in 1980 downstream of the original structure.

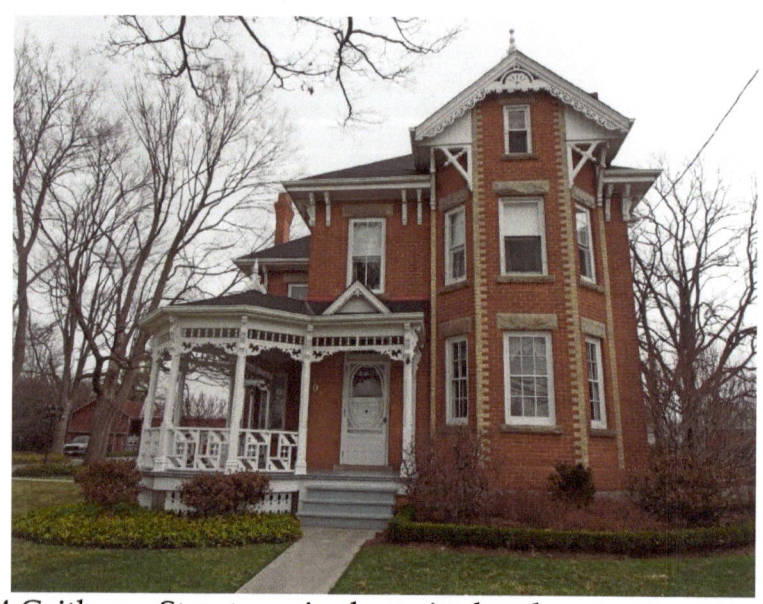

204 Caithness Street – paired cornice brackets, corner quoins, decorative verge board trim on gable of two-and-a-half-storey tower-like bay

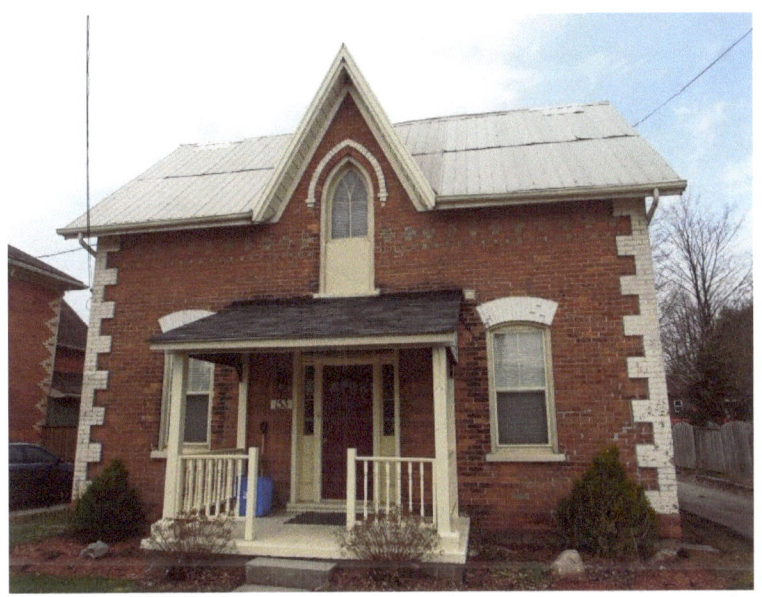

153 Argyle Street – Gothic Revival cottage, corner quoins, decorative brickwork

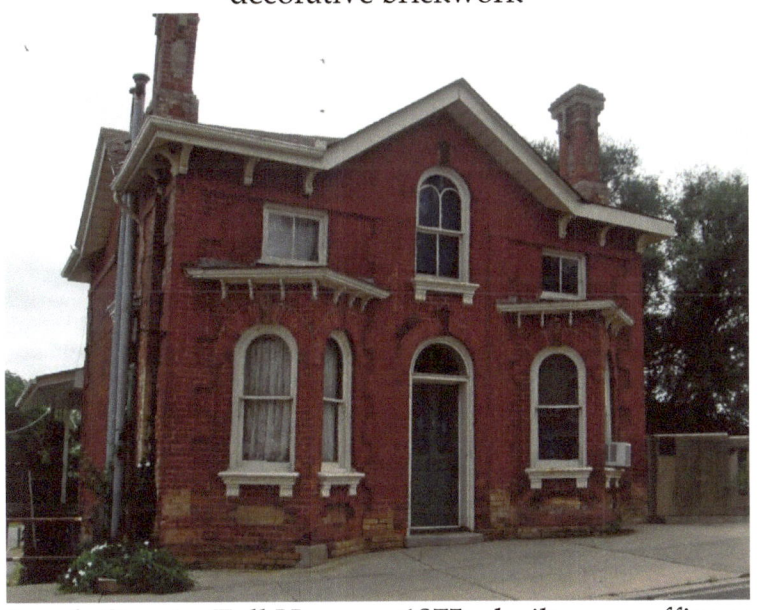

4 Argyle Street – Toll House c. 1875 – built as an office and residence for the collector of tolls for the bridge over the Grand River

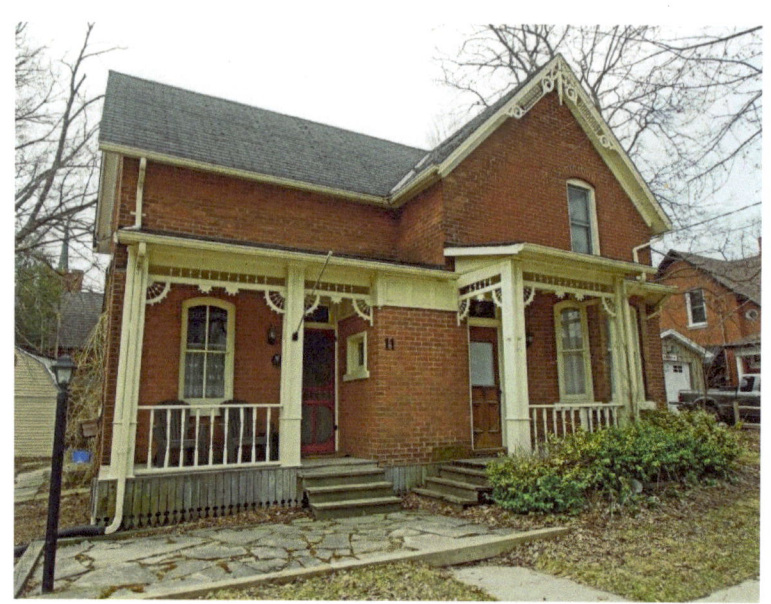

11 Orkney Street – Gothic Revival

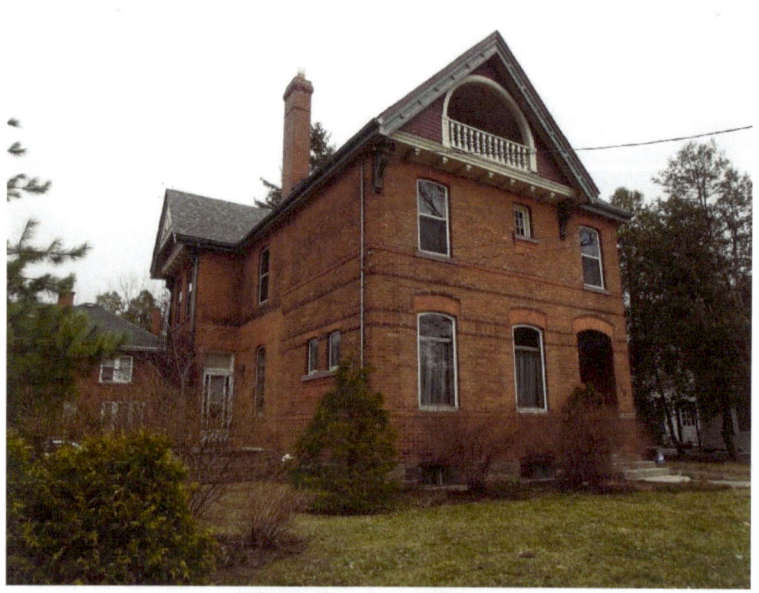

78 Sutherland Street

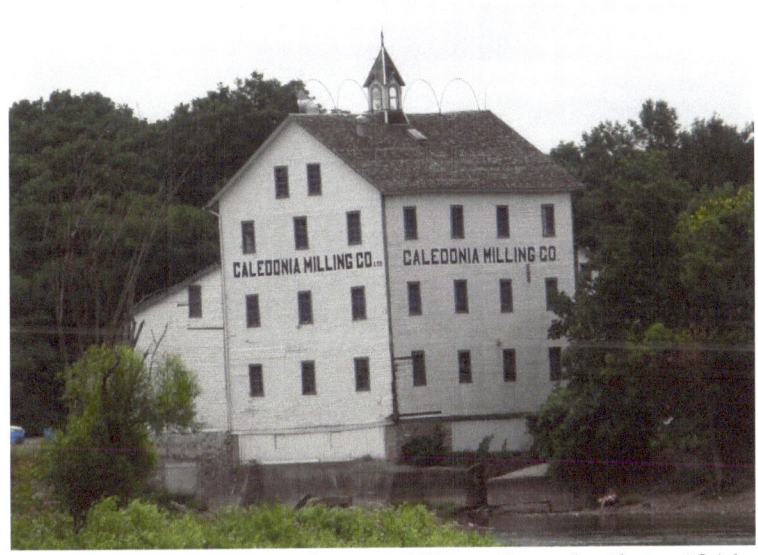

Grand River Mills – Caledonia Milling Co. – built in 1846 - the last timber-frame water powered mill along the Grand River in Ontario

Simcoe, Ontario – My Top 6 Picks

Simcoe is a town in Southwestern Ontario located near Lake Erie at the junction of Highways 3 and 24, south of Brantford. From Hamilton take Highway 6 to Simcoe.

Simcoe was founded in 1795 by Lieutenant-Governor John Graves Simcoe. He gave a grant to Aaron Culver, one of the earliest settlers, with the condition that he was to build mills. In 1801 he built a sawmill and a few years later added a grist mill. The combined operation known as Union Mill was instrumental in the development of Simcoe. By 1812 a hamlet had grown up around the mills. The mills were burnt and the adjacent houses looted by U.S. troops in 1814. In 1819-23, Culver laid out a village which he called Simcoe. The mill was rebuilt by Duncan Campbell around 1825. By the 1870s, Nathan Ford operated a large flour mill, grain elevator and distillery on this site. The last water-powered mill on this site ceased operations in 1928.

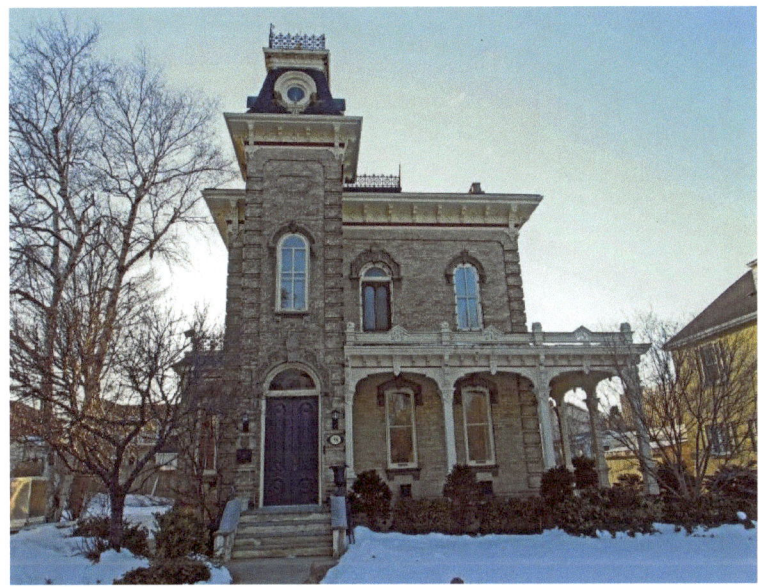

94 Norfolk Street – Italianate style with two-and-a-half storey tower-like bay topped with a cupola with iron cresting on top; decorative voussoirs and keystones

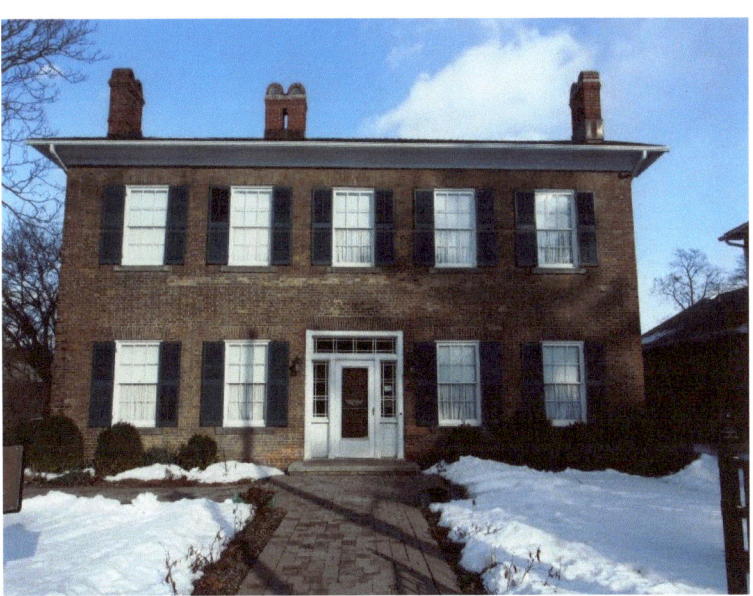

109 Norfolk Street South - Eva Brook Donly Museum – Georgian style

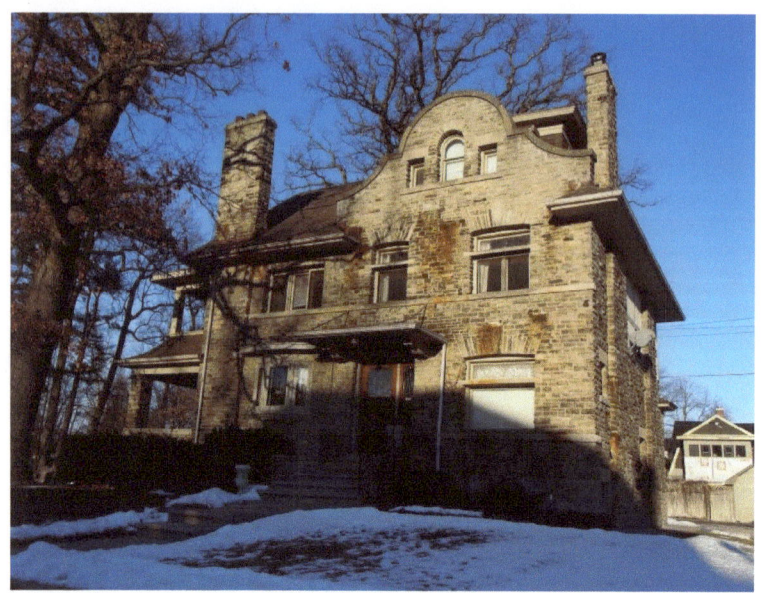

Norfolk Street at corner of Lynn Park Drive - Stone mansion, Palladian window in round gable, decorative voussoirs, deep verandahs, enclosed verandah on second floor at rear

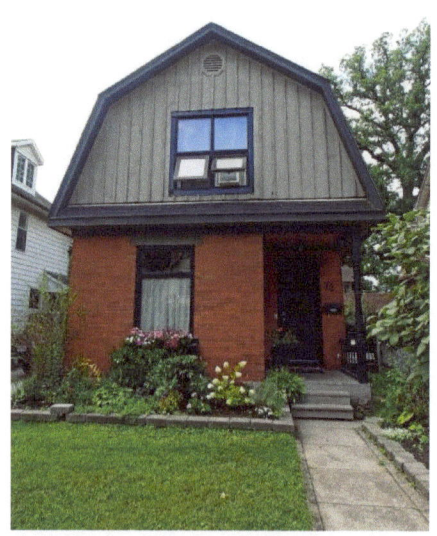

72 Lynwood Drive – Neo-colonial style, gambrel roof

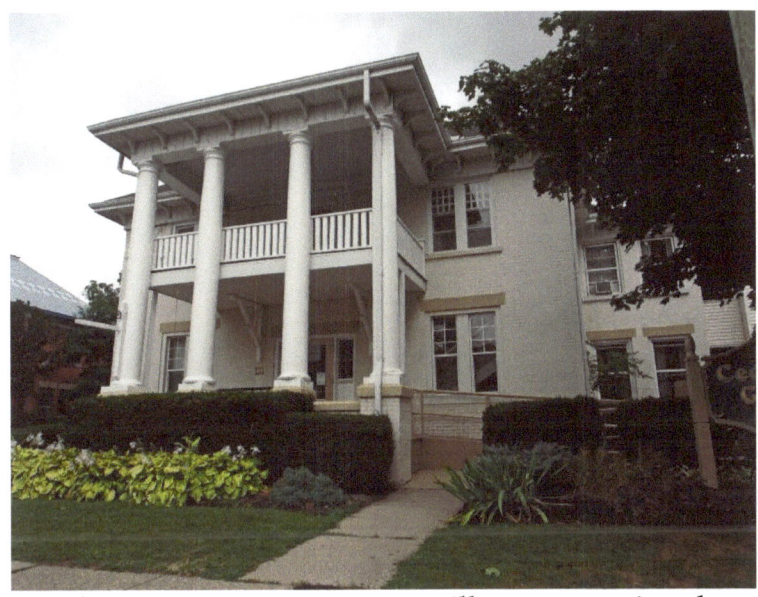

121 Colborne Street – two-storey pillars supporting the roof with verandahs on both levels

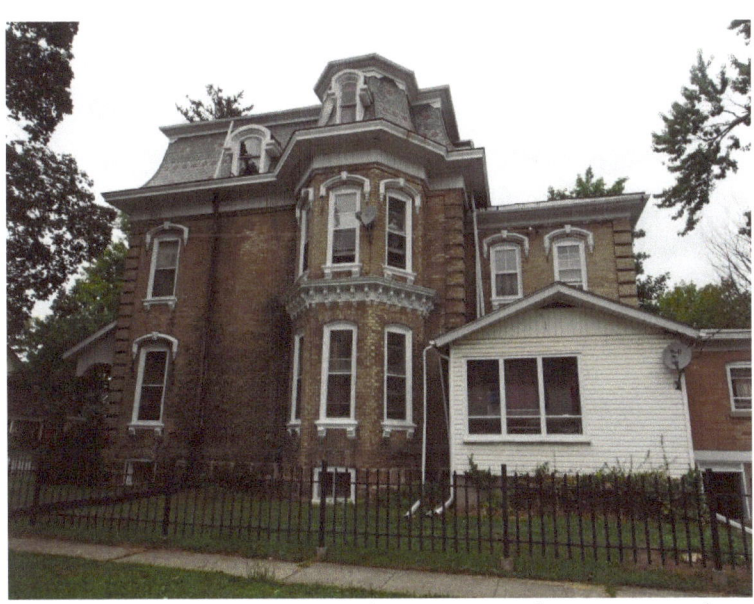

217 Colborne Street – Second Empire style – mansard roof, dichromatic tilework

Galt, Ontario – My Top 6 Picks

In 1784 the British Crown granted to the Six Nations Indians, in perpetuity, all the land along the Grand River six miles deep on each side of the river from its source to Lake Erie. The Indians, led by Joseph Brant, had the land surveyed in 1791 and divided into Indian Reserve lands as well as large tracts which they intended to sell to land developers. One such developer was the Honorable William Dickson who, in 1816, came into sole possession of 90,000 acres of land along the Grand River which later made up North and South Dumfries Townships.

It was Mr. Dickson's intention to divide the land into smaller lots to sell to the Scottish settlers that he hoped to attract to Canada. For the town site, the place where Mill Creek flows into the Grand River was chosen and in 1816 the settlement of Shade's Mills began. When the Post Office opened in 1825, the new name of Galt was chosen for the town in honor of the Scottish novelist and Commissioner of the Canada Company, John Galt.

In its early days Galt was an agricultural community serving the needs of the farmers in the surrounding countryside. By the late 1830s, the settlement began to develop industrially and acquired the reputation for quality products that in later years earned the town the nickname "The Manchester of Canada".

In the late 1960s the provincial government began looking at ways in which municipal governments could become more effective. On January 1, 1973, the City of Galt was amalgamated with the towns of Preston and Hespeler to form a single city, the new city being called Cambridge.

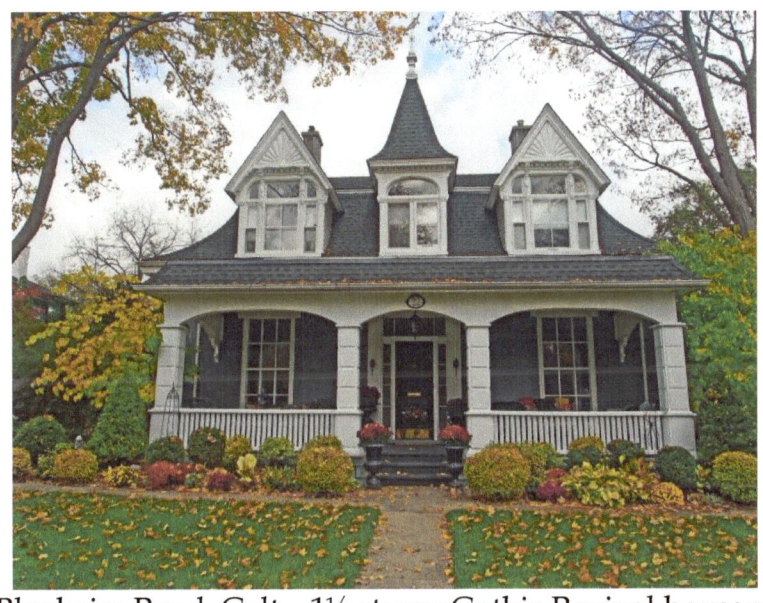

22 Blenheim Road, Galt – 1½ storey Gothic Revival house with large dormers in the attic – Galt Book 1

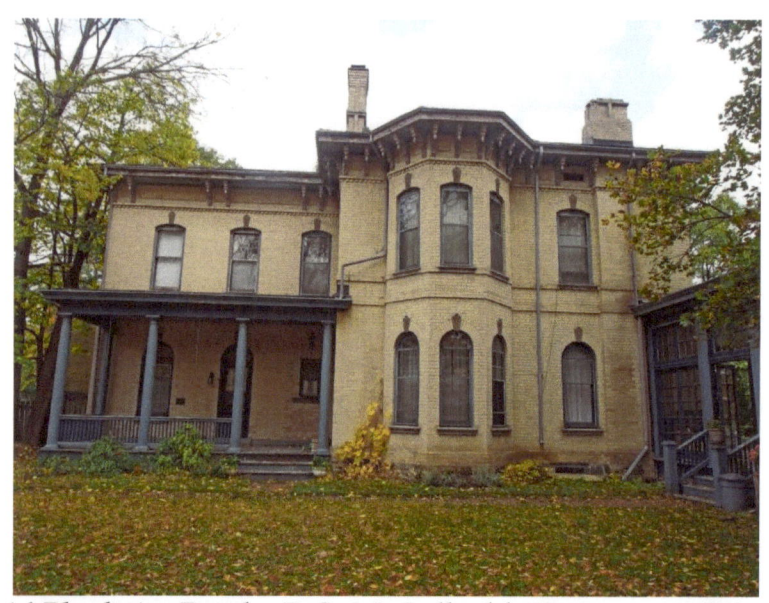

16 Blenheim Road – R.O. McCulloch's House – c. 1879 – yellow brick, Italianate style – cornice brackets, dentil moulding, decorative concrete keystones, wooden logia-style porch. Robert McCulloch was heir to Goldie-McCulloch Co. Ltd., the forerunner of Babcock & Wilcox Canada.
– Galt Book 1

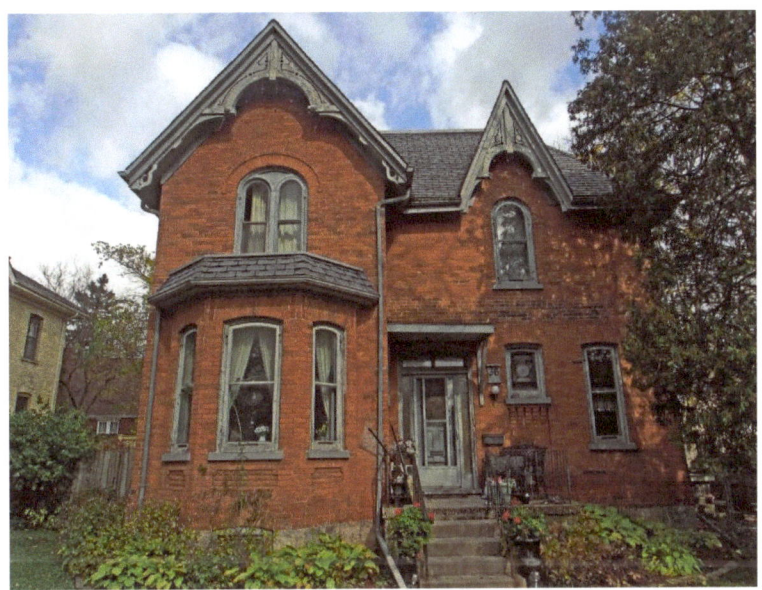

36 Blenheim Road – red brick Gothic Revival - verge board trim on gables, bay window – Galt Book 1

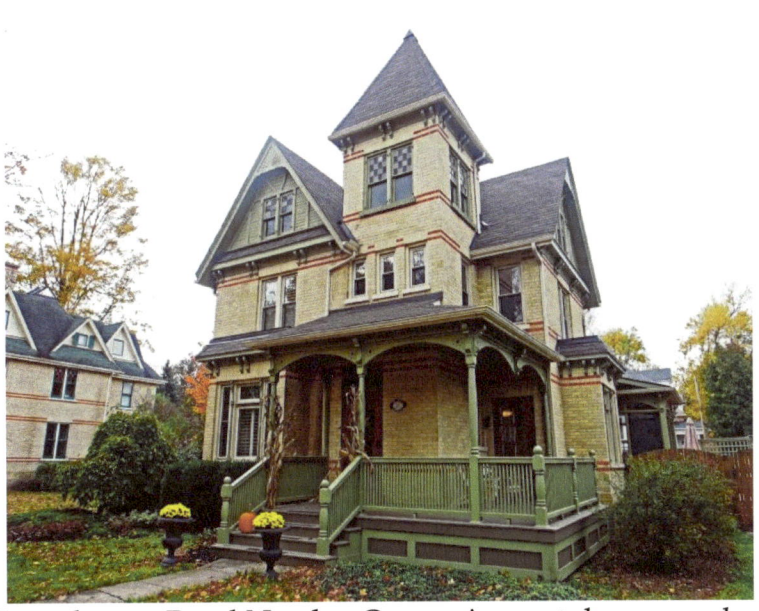

26 Lansdowne Road North – Queen Anne style – verge board trim on gable, dichromatic brickwork, cornice brackets on bay window – Galt Book 1

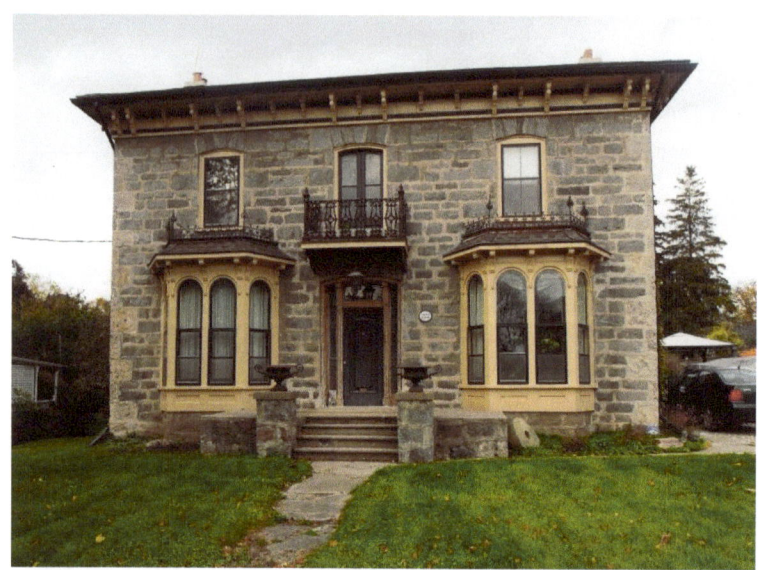

222 Main Street – Italianate – cornice brackets, iron cresting above bay windows and around 2nd floor balcony, cornice brackets, hipped roof– Galt Book 2

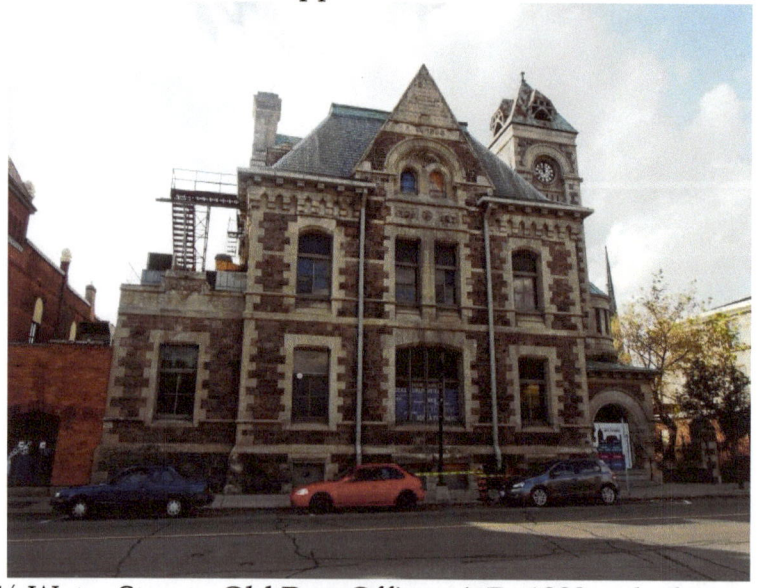

12½ Water Street - Old Post Office– A.D. 1883 – clock tower– Galt Book 2

Hespeler, Ontario – My Top 5 Picks

The area of Hespeler was originally part of the land granted to the Six Nations Indians by the British Crown in 1784. The Indians led by Joseph Brant sold part of their block of land measuring 90,000 acres to Richard Beasley and his partners. A group of Pennsylvania Mennonites agreed to buy some of the land and began arriving in the Hespeler area in 1809. The most important of the area's early settlers was Jacob Hespeler, the man who gave the settlement its permanent name. Jacob Hespeler was born in Germany, educated in France and emigrated to Canada with eight of his brothers and sisters. In about 1835 he moved to the German community of Preston where he opened a store. He looked for land in order to build a grist mill and found a suitable site on the Speed River in the settlement of New Hope. He also built a sawmill, a cooperage, a gas house, a distillery and a stone woollen mill. The name of the village was changed to Hespeler in 1859 with the arrival of the Great Western Railway.

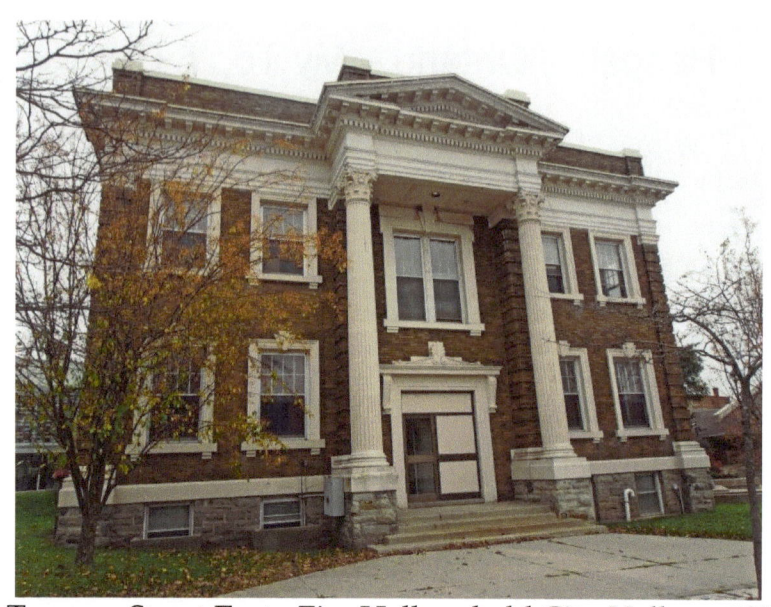

11 Tannery Street East - Fire Hall and old City Hall – c. 1914 - Beaux Arts style

32 Adam Street – 1½ storey Gothic Revival, corner quoins, verge board trim on gable, arched window voussoirs

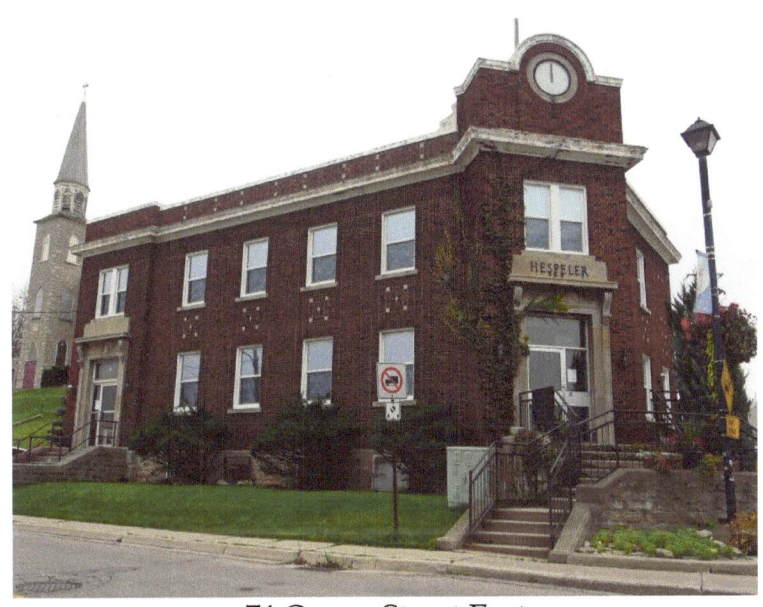

74 Queen Street East

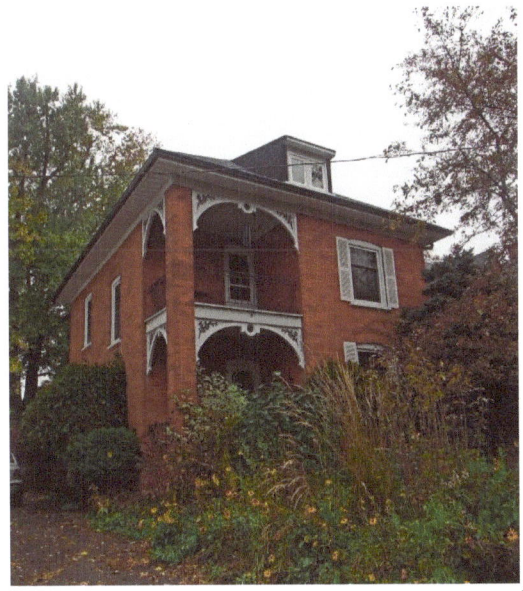

Guelph Avenue – Italianate – dormer in attic, decorative fretwork

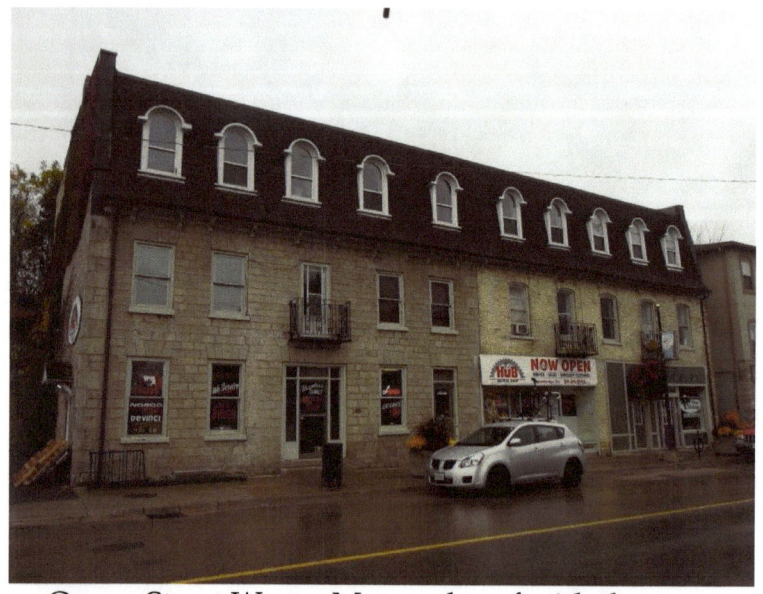
Queen Street West – Mansard roof with dormers

Preston, Ontario – My Top 6 Picks

John Erb, the founder of Preston, was born in Lancaster County, Pennsylvania, a Mennonite of Swiss ancestry. He came to Upper Canada in 1805, acquired 7,500 acres of land from the German Land Company and settled on the site of Preston where the Grand and Speed Rivers meet. He built a sawmill and a gristmill and the community grew around them. The town was originally known as "Cambridge Mills" and was later renamed after Preston, England.

Preston's location on the Great Road into the interior of the province made it a natural stop for travellers and with its eight hotels and taverns attracted more Europeans than any other village in the area.

Preston was a prosperous manufacturing centre for stoves, furniture, wools and shoes. It became known for its mineral springs.

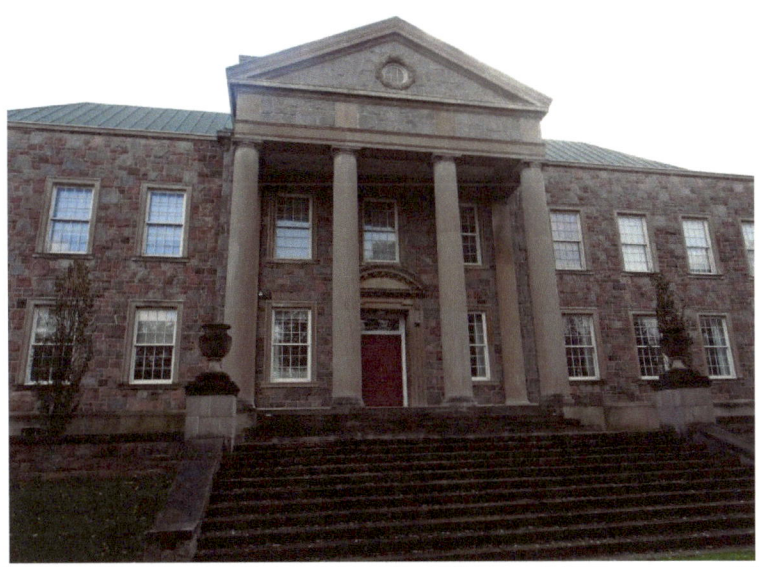

252 Dundas Street, Preston – Gore Mutual Insurance – 1935

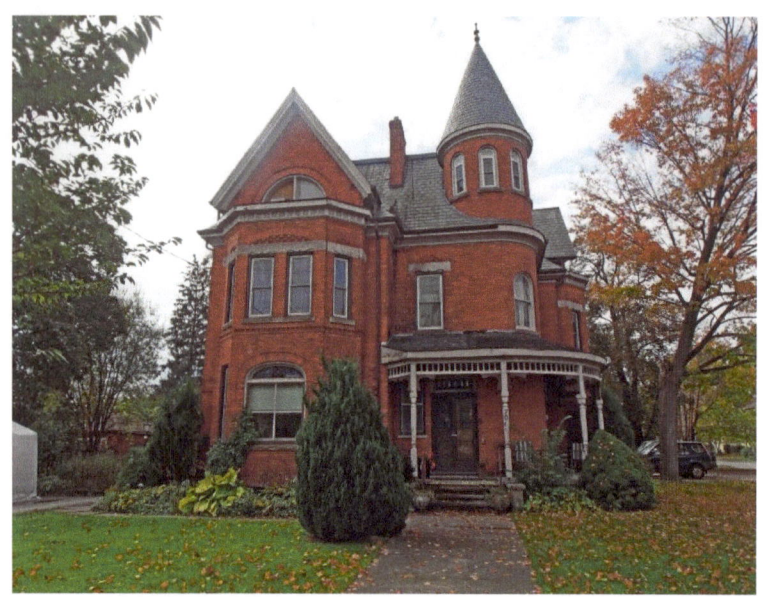

706 Queenston Road – Queen Anne style - a two-and-a-half storey tower-like bay with gable, three-storey tower with cone-shaped roof

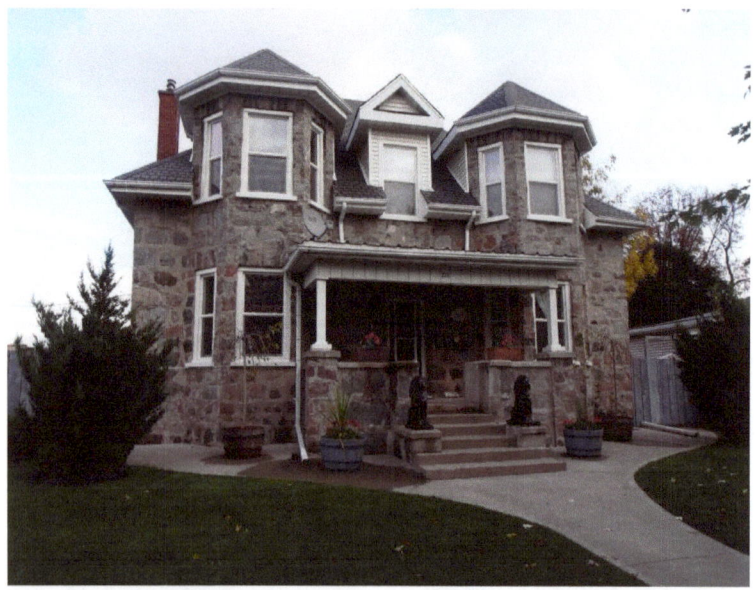

222 Dundas Street, Preston – cobblestone architecture – Italianate with two-storey tower-like bays on either side of the doorway; dormer in attic between the bays

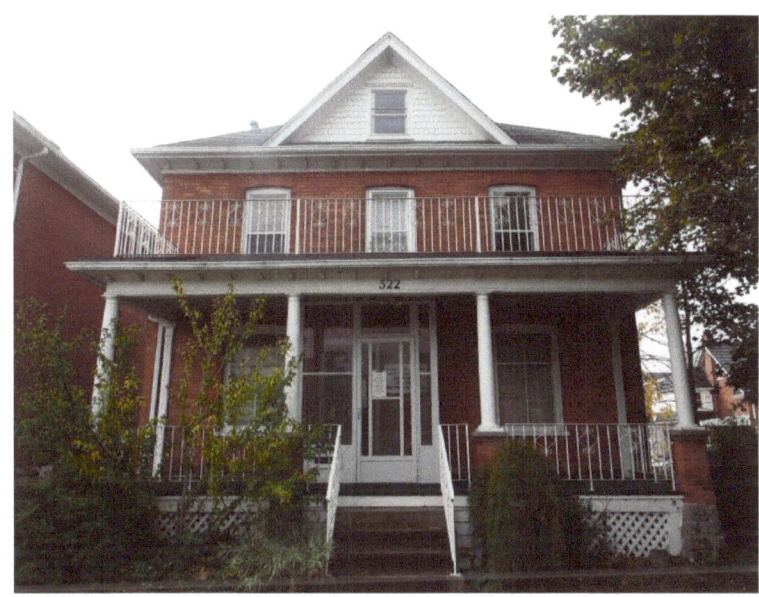

522 King Street – two storey Italianate style with dormer in attic

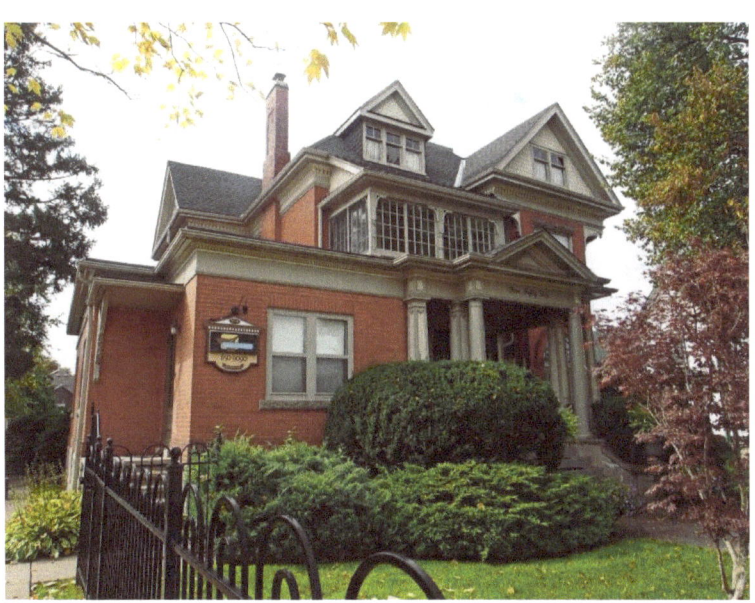

552 King Street - Italianate style - two-and-a-half storey tower-like bays with projecting eaves and large fretwork pieces resembling brackets

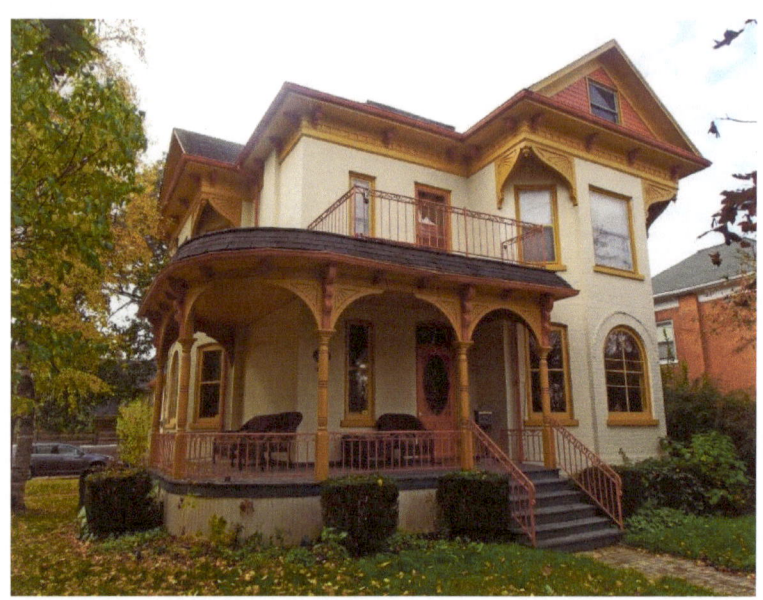

480 Queenston Road – Italianate with a two-and-a-half storey tower-like bay with projecting eaves and large fretwork pieces resembling brackets

Kitchener, Ontario – My Top 6 Picks

Kitchener is located in Southwestern Ontario in the Grand River Valley. The settlement's first name, Sand Hills, is an accurate description of the higher points of the Waterloo Moraine which snakes its way through the region and holds a significant quantity of artesian wells from which the city gets most of its drinking water.

In 1784, the land that Kitchener was built upon was an area of 240,000 hectares of land given to the Six Nations by the British as a gift for their allegiance during the American Revolution. The Six Nations sold 38,000 hectares of this land. The land was remote but of great interest to German Mennonite farming families from Pennsylvania who wanted to live where they could practice their beliefs without persecution. The Mennonites created 160 farm tracts. One of the Mennonite families, arriving in 1807, was the Schneiders, whose restored 1816 home (the oldest building in the city) is now a museum located in the heart of Kitchener.

Much of the land, made up of moraines and swampland interspersed with rivers and streams was converted to farmland and roads. Apple trees were introduced to the region by John Eby in the 1830s, and several grist and sawmills were erected throughout the area.

In 1833 the town was renamed Berlin. The extension of the Grand Trunk Railway from Sarnia to Toronto and through Berlin in July 1856 was a major boon to the community helping to improve industrialization in the area. Through the latter half of the 19th century and into the first decade of the 20th, the City of Berlin was a bustling industrial center celebrating its German heritage. When World War I started, that heritage became the focus of considerable enmity from non-German residents, and resulted in the name being changed to Kitchener.

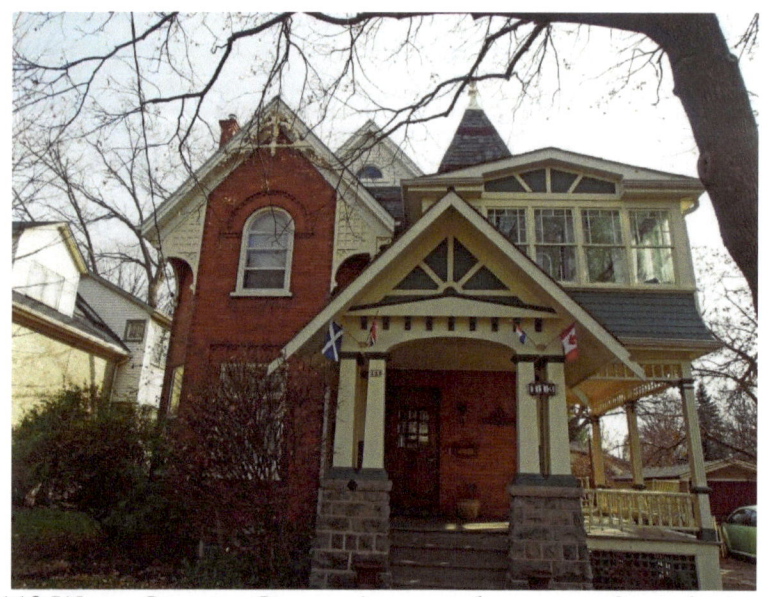

113 Water Street – Queen Anne style – verge board trim, fretwork brackets, second-floor sun room – Kitchener Book 1

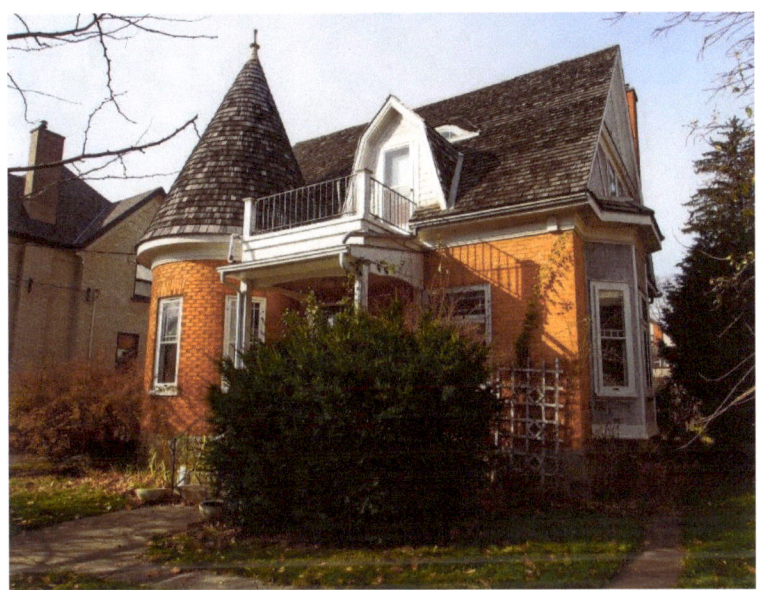

Water Street – Queen Anne eclectic style – one storey turret with cone-shaped roof, dormer in attic with balcony on second floor, bay window on the side – Kitchener Book 1

28 Weber Street – Second Empire style – mansard roof, dormers in roof – Kitchener Book 2

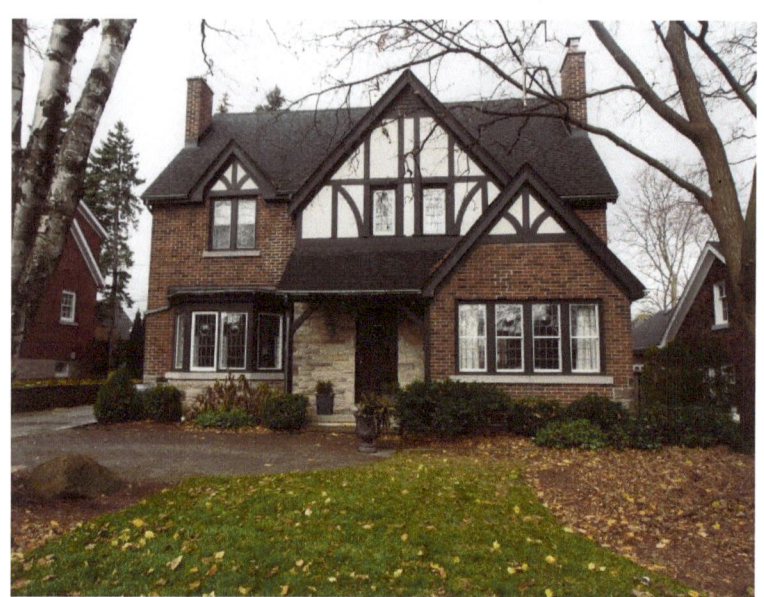

222 Pandora Crescent – Tudor style – Kitchener Book 2

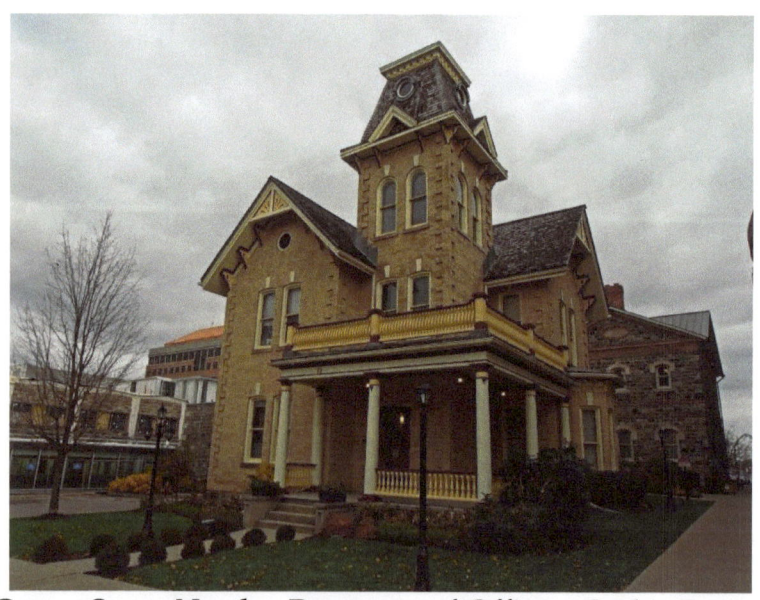

73 Queen Street North – Prosecutors' Office – Gothic Revival – decorative cornice brackets, arched window voussoirs with keystones, corner quoins – Kitchener Book 2

148 Margaret Street – Tudor half-timbering, two-storey tower with cone-shaped roof

St. Thomas, Ontario – My Top 5 Picks

Colonel The Honorable Thomas Talbot (1771-1853), the founder of the "Talbot Settlement", was born at Castle Malahide, Ireland. In 1803, after serving in the British Army, he was granted 5,000 acres and settled in Dunwich Township. He promoted colonization by building mills, supervising the construction of a three hundred mile long road paralleling Lake Erie, and helping establish thousands of settlers in the area. In 1817 St. Thomas, located south of London and north of Port Stanley, was named for him.

St. Thomas, located in Southwestern Ontario at the intersection of two historical roads, was first settled in 1810. It was named the seat of the new Elgin County in 1844 and became a city in 1881. The founder of the settlement was Captain Daniel Rapelje. In 1820, Rapelje divided his land into town lots for a village and he donated two acres of land for the building of Old St. Thomas Church.

On September 15, 1885, Jumbo, the giant African elephant, star of the Barnum & Bailey Circus, met an untimely death when struck in St. Thomas by a Grand Trunk locomotive. A life-size commemorative statue was erected in 1985.

In the late nineteenth century and early twentieth century several railways were constructed through the city and St. Thomas became an important railway junction. In the 1950s and 1960s, with the decline of the railway as a mode of transportation, other industry began to locate in the city, mainly primary and secondary automotive manufacturing.

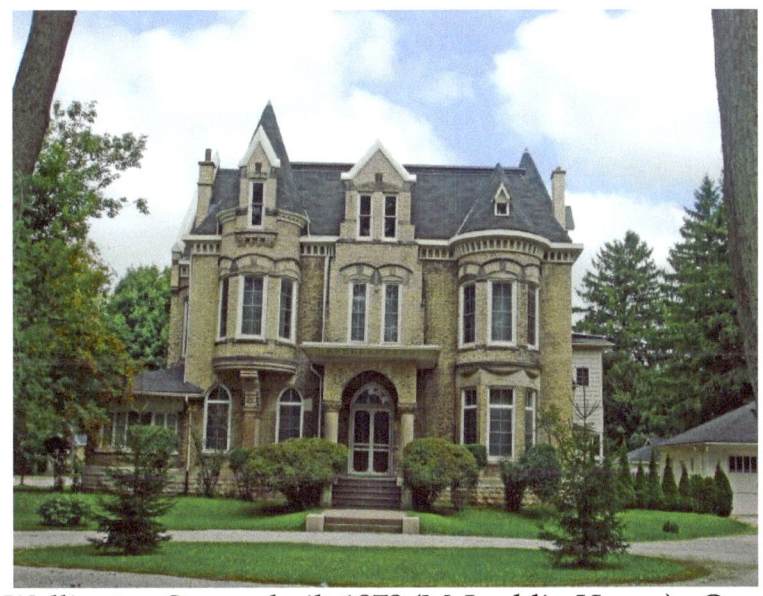

1 Wellington Street - built 1878 (McLachlin House) - Queen Anne style – turrets, scroll work, bracketing, dormers

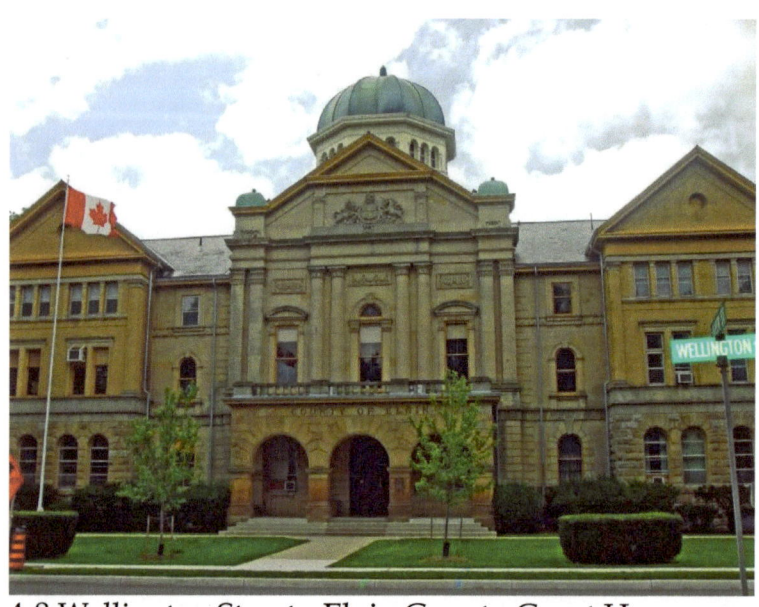

4-8 Wellington Street - Elgin County Court House was originally designed by architect John Turner and built in 1854. After a fire in 1898, the original building was repaired and enlarged by architect N.R. Darrach, resulting in the present Palladian style, expressed by its symmetry, rectangular and round-arched openings, and by the use of classic detailing.

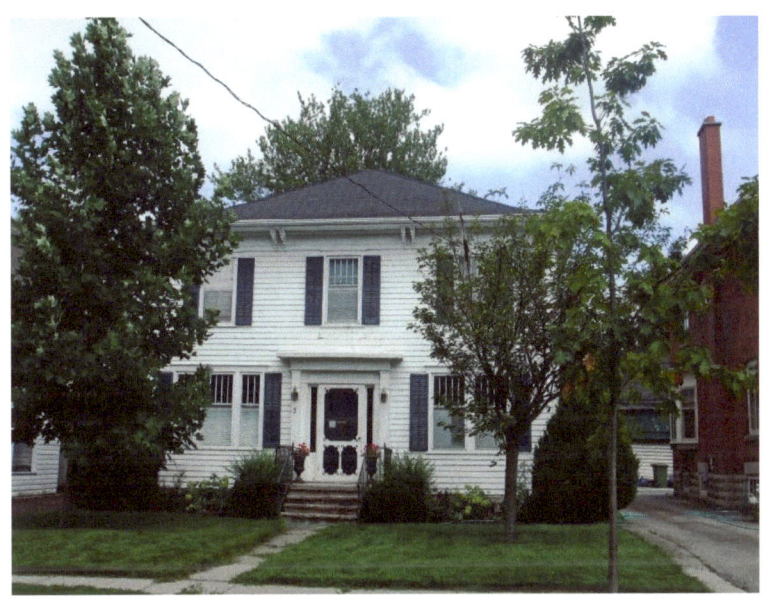

3 Drake Street – built 1876 – Georgian frame house – paired cornice brackets

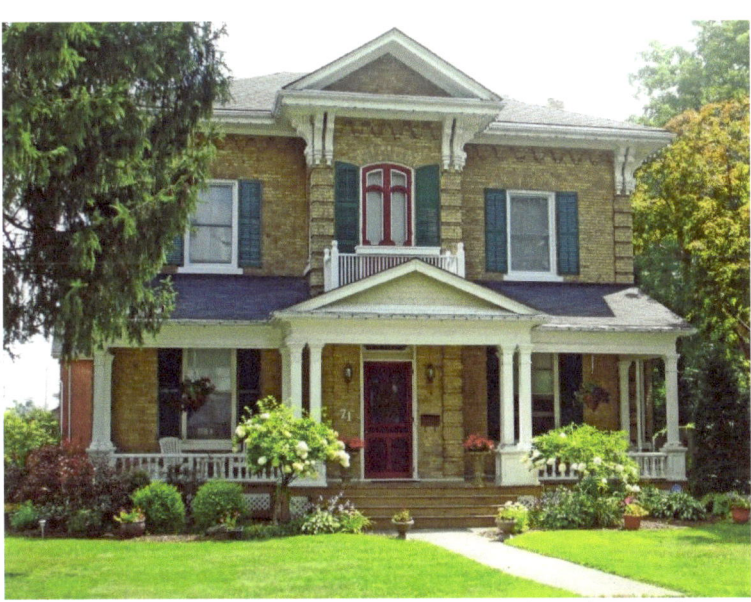

71 Metcalfe Street – Georgian with three-bay front, the centre bay projects forward, pediment, cornice brackets

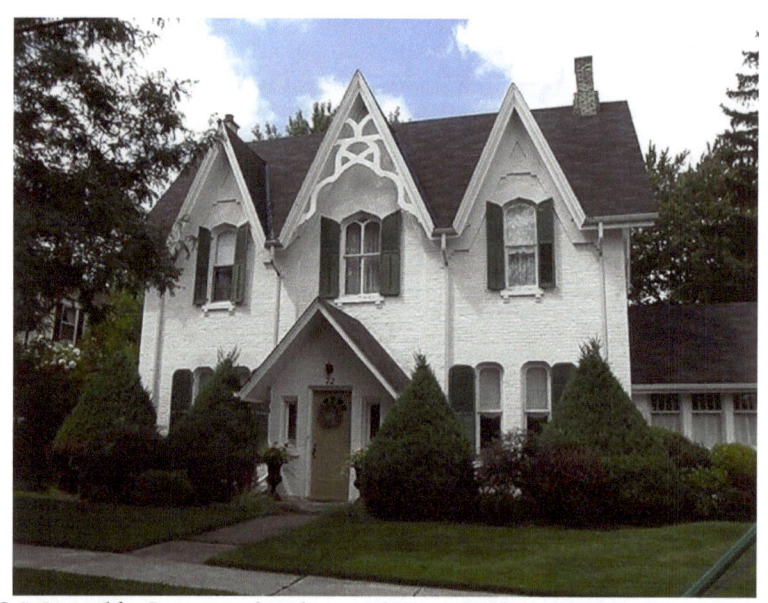

72 Metcalfe Street – built in 1875 - Gothic Revival – sharply peaked roof, intricate verge board trim

Stratford, Ontario – My Top 6 Picks

Stratford is a city on the Avon River in Perth County in southwestern Ontario located at the junction of Highways 7-8 and 19. When the area was first settled by Europeans in 1832, the town site and the river were named after Stratford-upon-Avon, England.

In 1832, the Canada Company, a large private land settlement agency, initiated the development of "Little Thames" as the market center for the eastern Huron Tract. By 1834, a tavern, sawmill, and gristmill were built and a year later a post office called Stratford was opened. With the coming of the railroad in the 1850s and the designation of Stratford as county town, the village was transformed into a thriving administrative and commercial center. Railway repair yards were opened here in 1871, and the town continued to expand. By 1885, Stratford had a population of 9,000 and it was incorporated as a city.

Furniture manufacturing became an important part of the local economy by the twentieth century.

The town is well known for being the home of the Stratford Shakespeare Festival which began in 1953. The annual festival brings hundreds of thousands of theatre goers and tourists to the area. The world-renowned festival takes place in four theatres throughout the city: the Festival Theatre, the Avon Theatre, Tom Patterson Theatre and the Studio Theatre.

The swan has become a symbol of the city. Each year twenty-four white swans and two black swans are released into the Avon River.

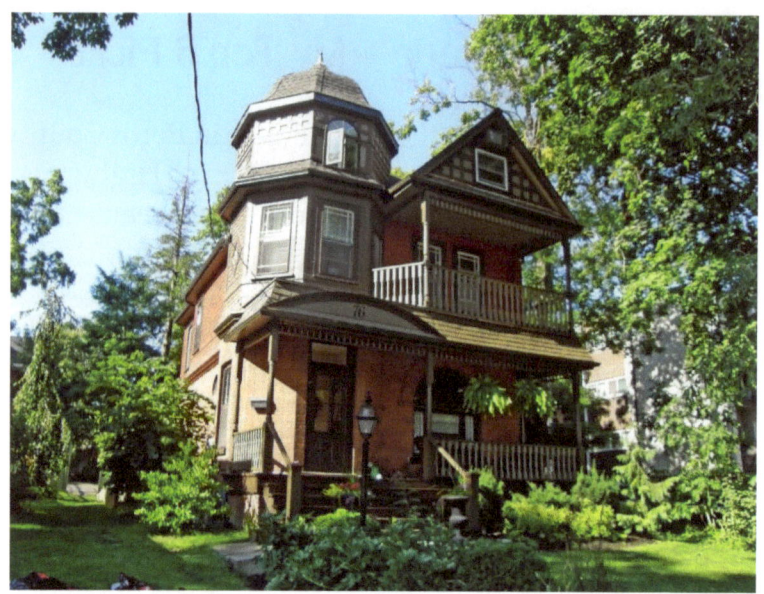

76 Mornington Street - Queen Anne Style – turret

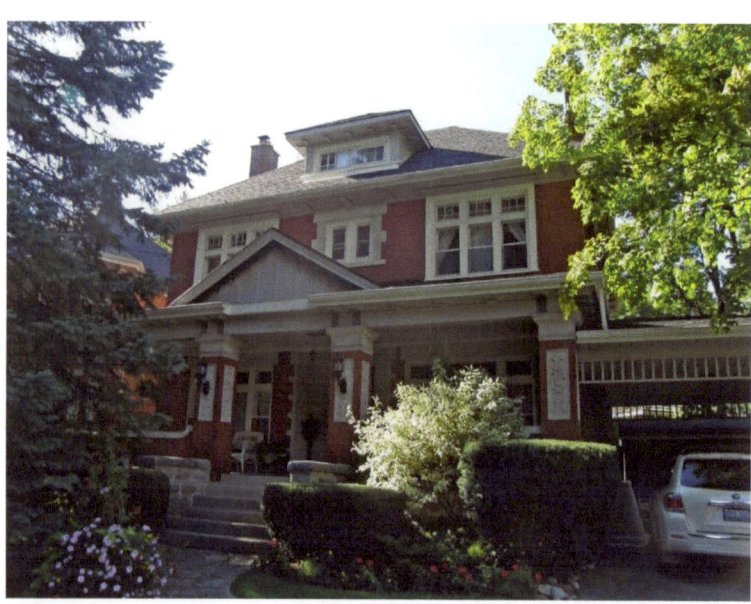

160 Mornington Street – Italianate, pediment, dormer in attic

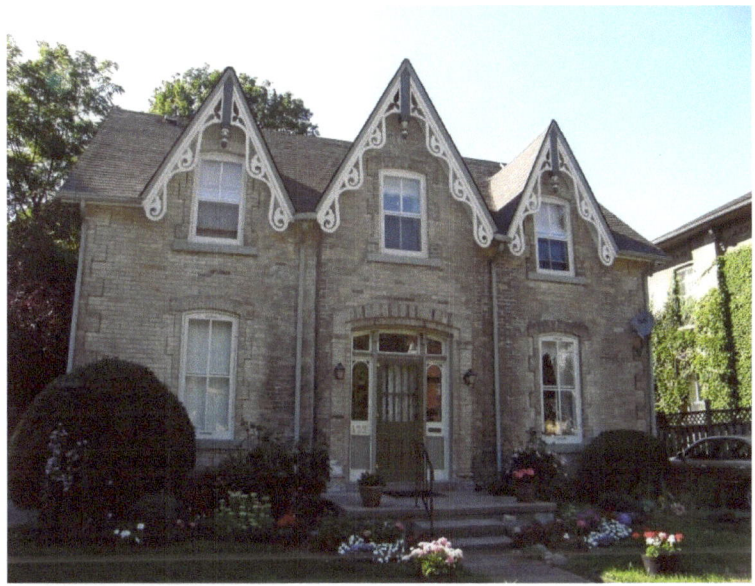

122 Mornington Street – Gothic Revival triple-gabled home, verge board trim on gables, finials, corner quoins; front door has bracketed transom and sidelight windows

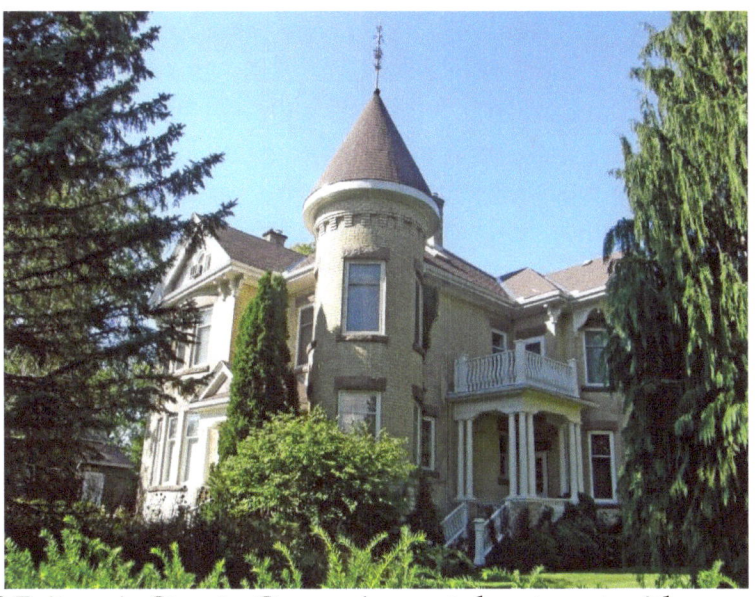

2 Britannia Street - Queen Anne style – turret with cone-shaped cap

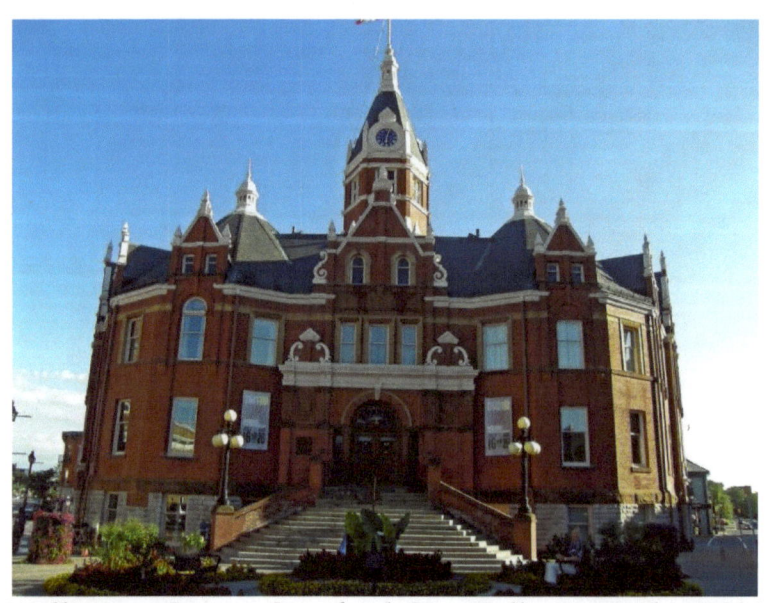

1 Wellington Street - Stratford City Hall – opened in 1900 – High Victorian building with many Queen Anne features – textural and dichromatic wall materials, Flemish wall dormers, and Neo-Classical cupolas and arches – geometric building with a dodecagon (twelve-sided shape) on either side of the outside triangular stairwell

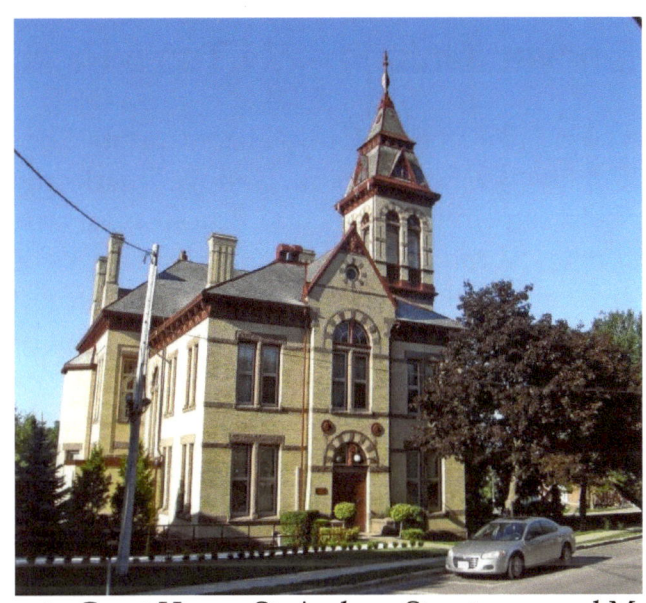

Perth County Court House, St. Andrew Street – opened May 9, 1887 – High Victorian architecture with terra cotta details

It combines multi-colored masonry and a variety of building materials with features from different architectural styles. Italianate brackets adorn the cornice, while several Queen Anne features include the medieval tower, molded brick chimneys, and small multiple paned windows. Romanesque Revival style features include the round arch windows stretching over two storeys, the heavy doors, the contrasting masonry surfaces, the rusticated basement foundation, the wall dormers which peak with a gable at the top, the pinnacle placed off center, Romanesque motifs adorning the soffits, and miniature columns complete with capitals which embellish the arched windows on the front and side facades. The soffits of the cornice immediately above the terra cotta panel are adorned with an intricate rose and maple leaf pattern.

Above the main entranceway is a semicircular transom, with stained glass windows portraying the scales of justice and crossed swords. Two panels with hands giving benediction are also located here. Quoins are used to create a pilaster effect complete with capitals on either side of the entrance, giving a contrast against the buff-colored brick.

Hanover, Ontario – My Top 5 Picks

Hanover is located on Grey/Bruce County Road 4, east of Walkerton and west of Durham. Hanover marks the boundary between Grey County and Bruce County. In 1849, the first pioneer, Abraham Buck, stood on the banks of the Saugeen River and looked about him at the thick forest of hardwood timber where the deer, bear and wolf ran free. The sky was filled with wild pigeons and the streams teamed with fish. He expressed the words, "It is good for us to be here." Edward Goodeve opened one of the first stores. Henry Proctor Adams built the dam and the first mill and drew up plans for the village – a man of vision who could foresee the future growth of the town.

The village grew and prospered with large factories and new businesses manufacturing furniture, knitted goods, cement, milled products and other items. Roads were improved, street lighting was added, and facilities for education and recreation were built.

The coming of the railway enabled the factories to ship their goods from coast to coast and by the 1920s, the town was known for its fine furniture and given the title of "The Furniture Capital of Canada". During the depression, the large furniture factories and other associated plants kept on working with a reduced work force.

Hanover moved forward into the 1950s with factories continuing to manufacture fine, hardwood furniture, textiles, flour, processed food and kitchen cabinets.

The milk wagons were pulled by horses plodding from door to door along the shady streets, but this ended as larger grocery stores with refrigeration opened. New schools and additions were needed to meet the expanding numbers of children.

The decades from 1970 to the year 2000 saw the decline of manufacturing, especially in the large factory settings. The older factories producing hardwood furniture could not compete with the cheaper, imported products. Railway freight began to decrease as highways improved and transport trucking took over.

Smaller businesses replaced the giant factory complexes. The unused rail lines are now scenic walking trails.

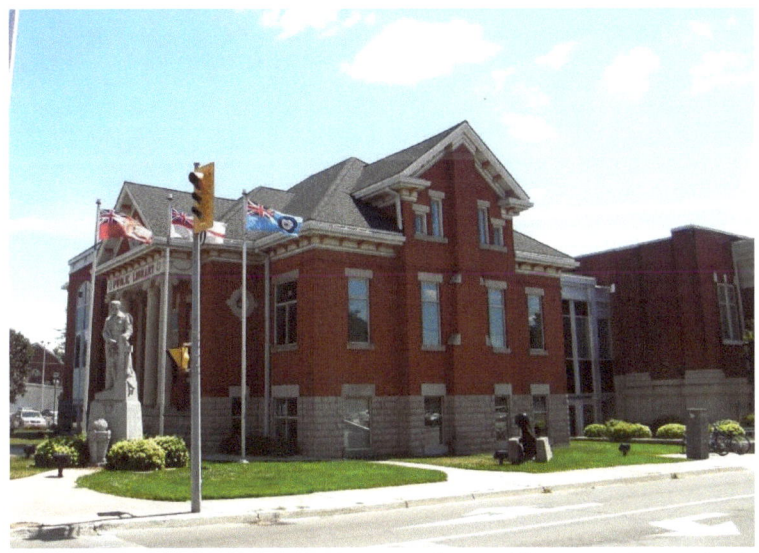

Public Library in Beaux Arts style – pillars with capitals, pediment with window in tympanum

Gothic Cottage

#512 – Italianate style, cornice brackets, two-and-a-half storey tower-like bay with decorative gable

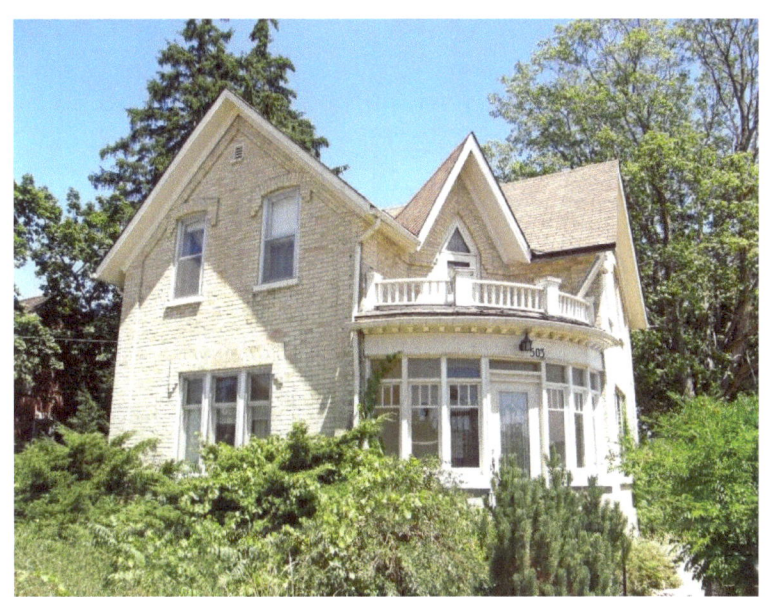

#503 – Gothic Revival

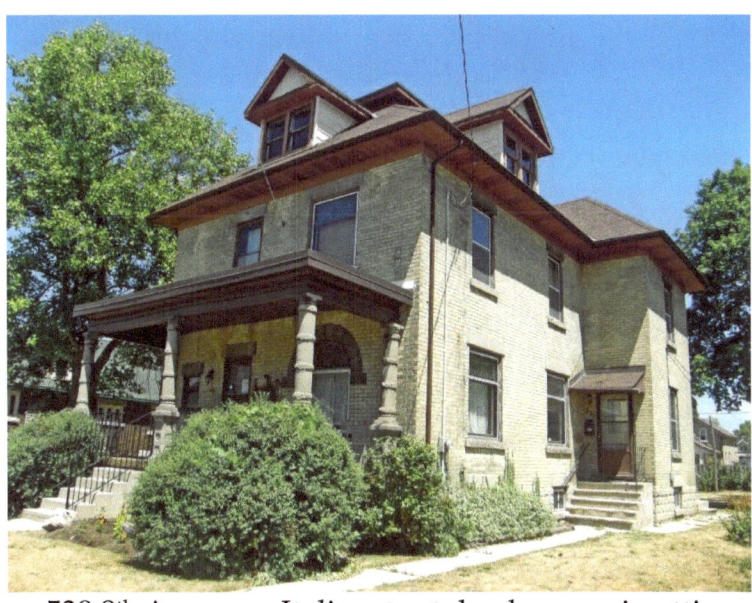

539 9th Avenue – Italianate style, dormers in attic

New Hamburg, Ontario – My Top 8 Picks

New Hamburg was established in the early 1830s by William Scott. In 1834, cholera killed many of the original settlers of New Hamburg. A grist-mill built by Josiah Cushman about 1834 formed the nucleus around which a small community of Amish Mennonites and recent German immigrants developed. More German and Scottish settlers arrived in the late 1830s and early 1840s. The Grand Trunk railway arrived in the 1850s and the village became an important centre for milling and the production of farm machinery.

New Hamburg is located in the rural township of Wilmot in the Regional Municipality of Waterloo. It is bordered by Baden to the east and is within easy driving distance of the cities of Kitchener, Waterloo and Stratford.

The Nith River winds through town and flows through the downtown core, which is home to a 50-foot waterwheel built in 1990, the largest operating water wheel in North America; it is a symbol of the importance of the Nith River, and of the water-powered mills which were the first industries in pioneer New Hamburg.

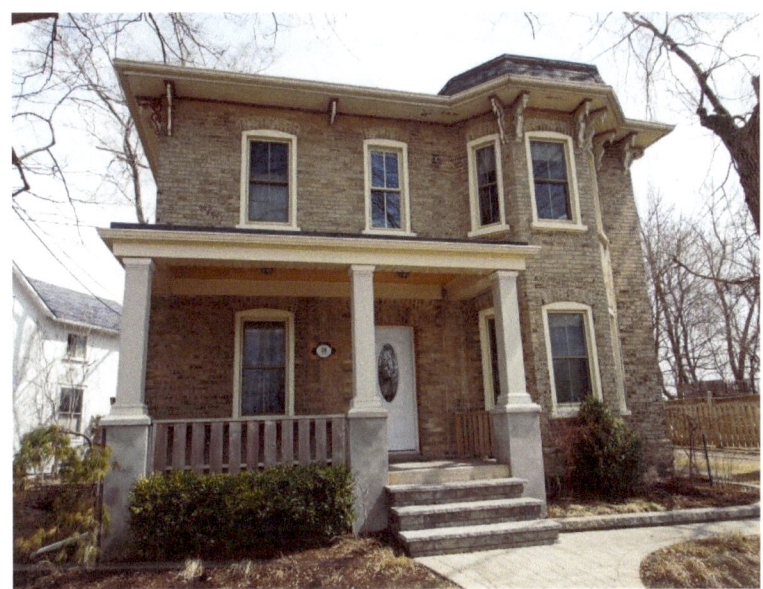

99 Byron Street – Italianate – cornice brackets

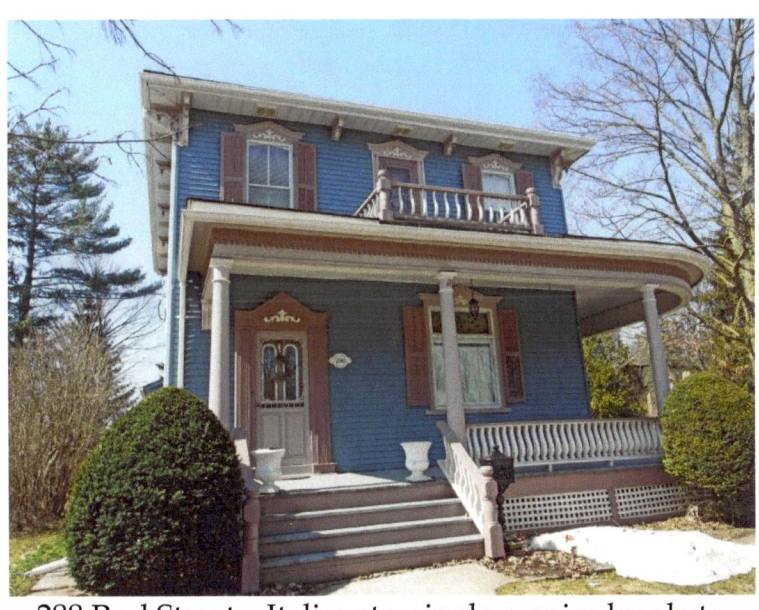

288 Peel Street – Italianate, single cornice brackets, wraparound verandah, balcony on second floor – Book 1

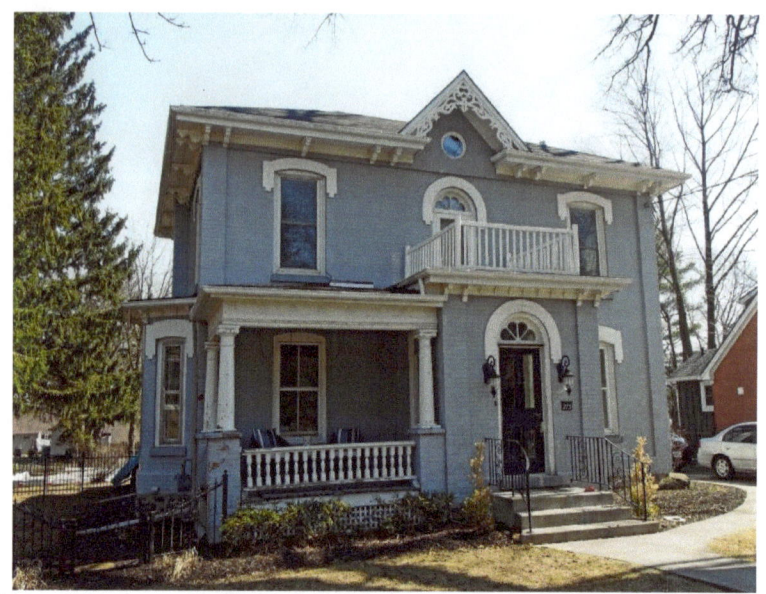

273 Peel Street – Italianate, cornice brackets, verge board trim, balcony second floor, bay window on side – Book 1

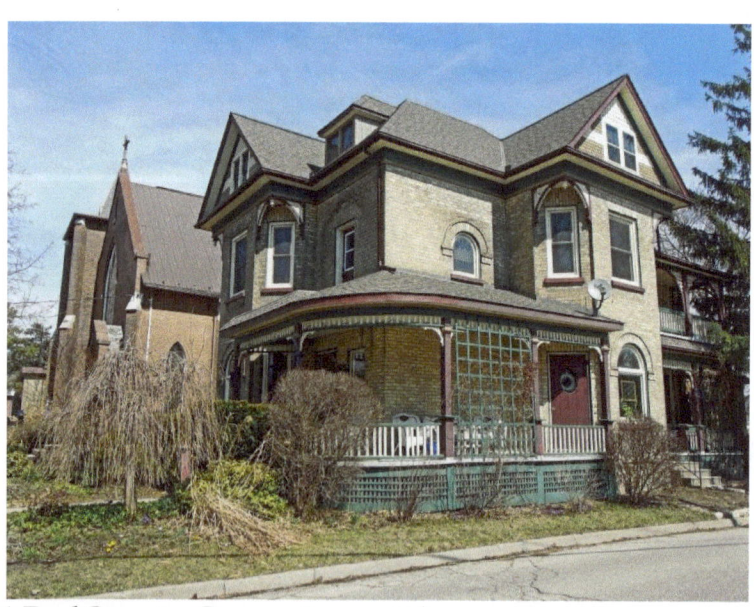

231 Peel Street – Queen Anne style - wraparound verandah, arched window voussoirs – Book 1

17 Huron Street – The William Scott House – Gothic style with Italianate features was built about 1846 - belvedere on roof, verge board trim on gables with finials. Now The Waterlot Restaurant – Book 1

159 Jacob Street – Italianate with two-and-a-half storey tower-like bay, iron cresting above porch roof – Book 2

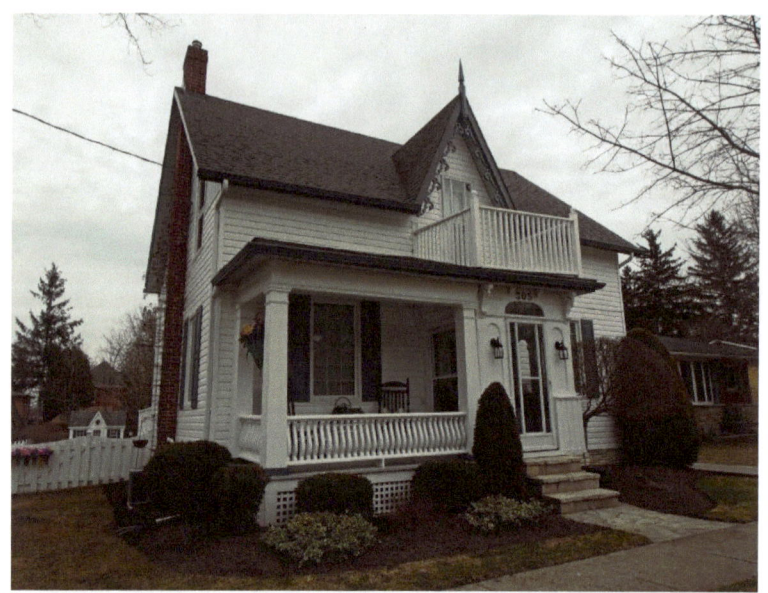

305 Wilmot Street – Gothic Revival, verge board trim on gable with finial, balcony on second floor – Book 2

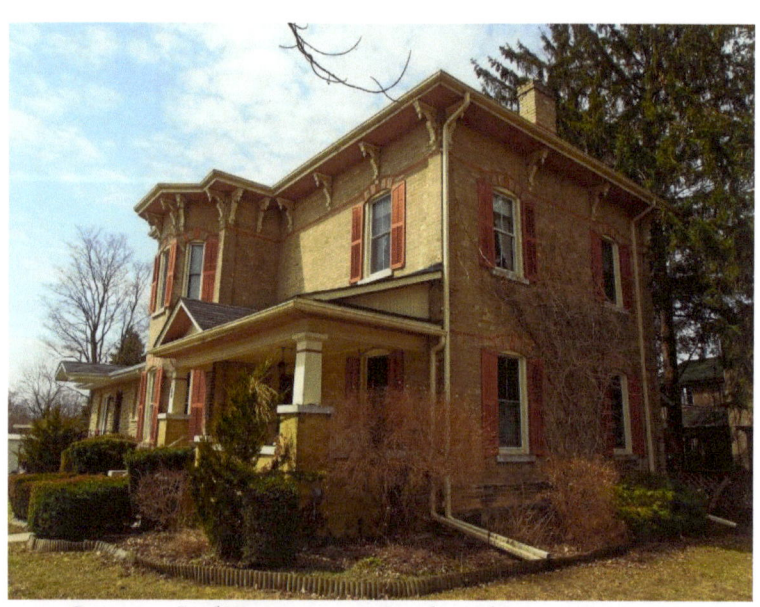

2 Byron Street – Italianate, cornice brackets, two-storey tower-like bay, dichromatic brickwork – Book 2

Waterdown, Ontario – My Top 7 Picks

Waterdown is located east of the junction of Highways 5 and 6, the intersection known as Clappison's Corners.

Established in 1792, the Township of Flamborough was named after a prominent geographical formation, the Flamborough Head, and the Town of Flamborough in East Yorkshire, England. The most striking aspect of Flamborough Head is the white chalk cliffs that surround it. The chalk lies in distinct horizontal layers with a layer of glacial deposits at the top of the cliffs.

Alexander Brown of the North West Fur Company purchased 800 acres and built a log cabin and sawmill at the top of the Great Falls in present-day Smokey Hollow in 1805. He was the first European settler in the region and was a key figure in the community throughout his lifetime. He moved down Grindstone Creek to the site of present-day LaSalle Park and built "Brown's Wharf". Smokey Hollow was the site of saw, grist, and flour mills, a woolen mill, a brass foundry, tanneries, rake, cradle, and basket factories. Brown built the first school of the village in 1815 on the site of the present-day American House, and employed Mary Hopkins as its first teacher. Entrepreneur Ebenezer Culver Griffin arrived in 1823, purchased more than half of Alexander Brown's property, and had his property surveyed in village lots, the true beginning of the Village of Waterdown.

In 1854, Flamborough was divided into two separate townships, East and West Flamborough. Included within East Flamborough was the town of Waterdown, named because of its close proximity to the place where Grindstone Creek tumbles over the Niagara Escarpment. Mills were built along the creek with the water harnessed to provide power.

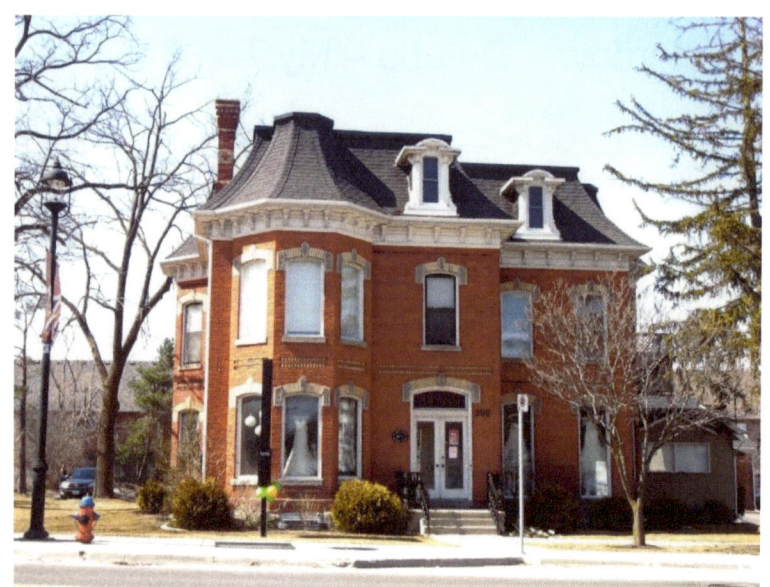

299 Dundas Street – Second Empire style, mansard roof, dormers in roof, cornice brackets, two-storey tower-like bays

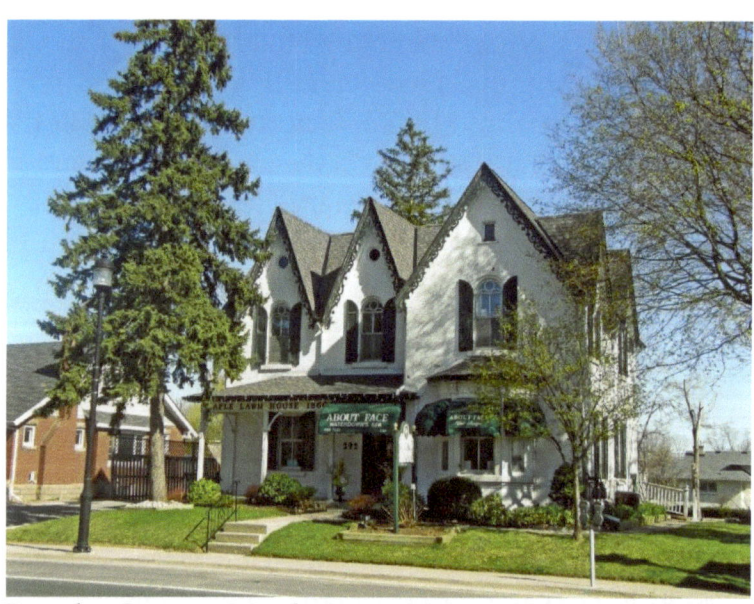

292 Dundas Street – Maple Lawn House 1860 - Gothic Revival, verge board trim on gables

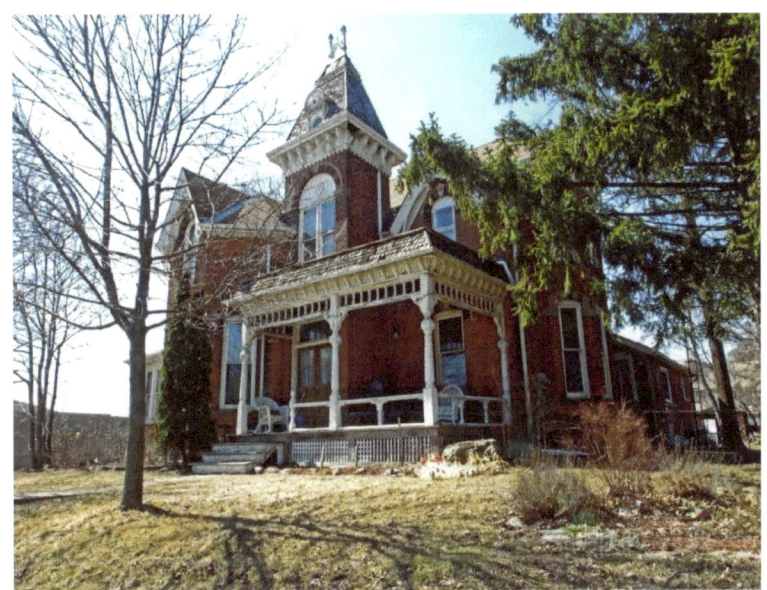

289 Dundas Street – Queen Anne style

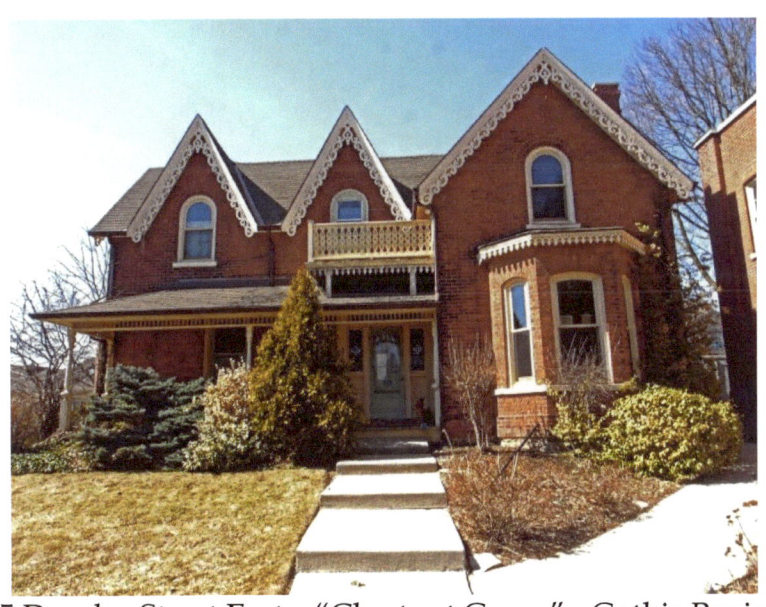

315 Dundas Street East – "Chestnut Grove" - Gothic Revival, verge board trim, first floor bay windows, built in 1880, second storey verandah

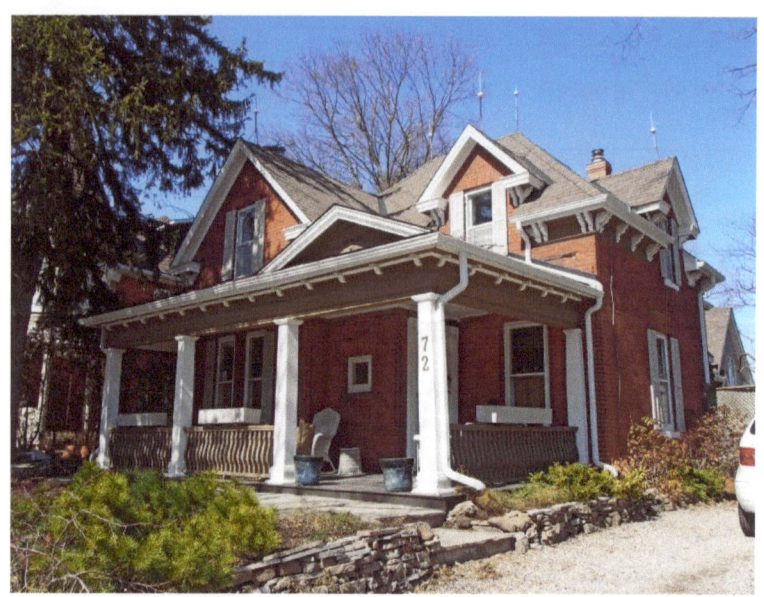

72 Mill Street – Gothic Revival, cornice brackets

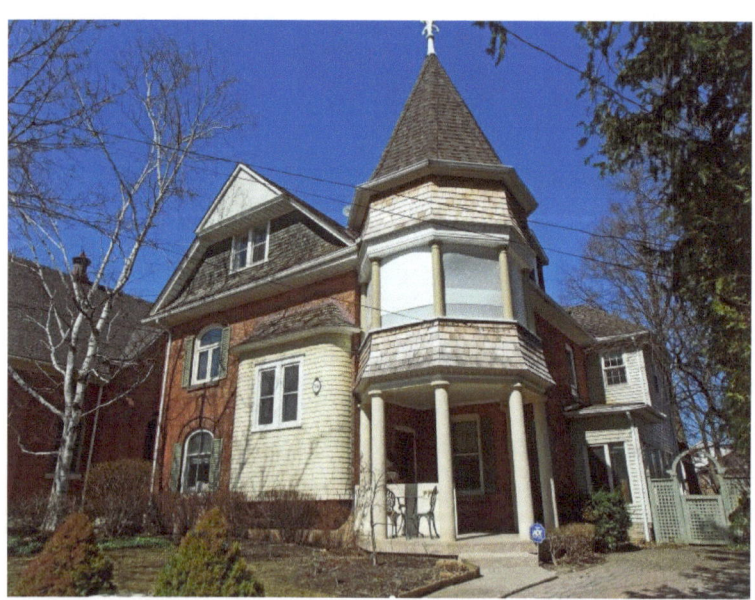

76 Mill Street – the Old Slater House – c. 1890 - Queen Anne style, two-storey octagonal tower, round Doric columns

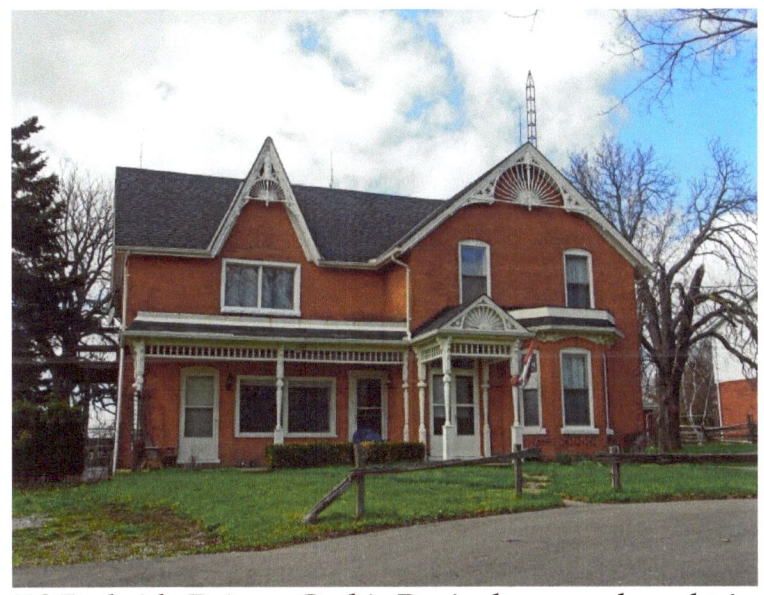

419 Parkside Drive – Gothic Revival – verge board trim

Stoney Creek, Ontario – My Top 6 Picks

Stoney Creek is located on the south-western shore of Lake Ontario into which feed the watercourse of Stoney Creek as well as several other minor streams. It was settled by Loyalists after the American Revolution. The Battle of Stoney Creek during the War of 1812 occurred near Centennial Parkway and King Street. In a surprise night-time attack, the outnumbered British overwhelmed the Americans and forced their retreat to Forty Mile Creek (the present location of Grimsby). In this forty minute battle, hundreds were killed and the two American Generals were captured. Battlefield Park has a monument and museum to preserve the history of this area.

Branches of the Bruce Trail provide access to Battlefield Park as well as the Devil's Punch Bowl which is marked by a large illuminated cross and offers an excellent lookout for Stoney Creek and Hamilton.

The Stoney Creek Dairy on King Street, with a stylized Battlefield Monument in its logo, offered frozen treats for decades. In 2013, the dairy was torn down for re-development. Eastgate Square Mall straddles the former border between Hamilton and Stoney Creek.

Due to the temperate environment, the Stoney Creek area is known for fruit growing. Most of the land mass of Stoney Creek remains agricultural. The communities of Elfrida, Fruitland, Tapleytown, Tweedside, Vinemount, and Winona are agricultural areas. Stoney Creek became a center for light industry, road transportation and commuting residences, since its land costs were much lower than in neighboring Hamilton.

E.D. Smith was established in 1878 in the Niagara Peninsula when a young farmer experimented with grapes, onions, hens, cows, sheep, grain, and a little patch of strawberries. The place was 120 acres tucked under the protective shadow of the Escarpment in Ontario's Niagara Peninsula. He hoped to make a living by harvesting the strawberries and taking the fruit to market. The juicy strawberries that grew so well in this rich soil were the beginning of a food empire. Its current product line includes jams and spreads, syrups, pie fillings, ketchup, sauces, and salad dressings.

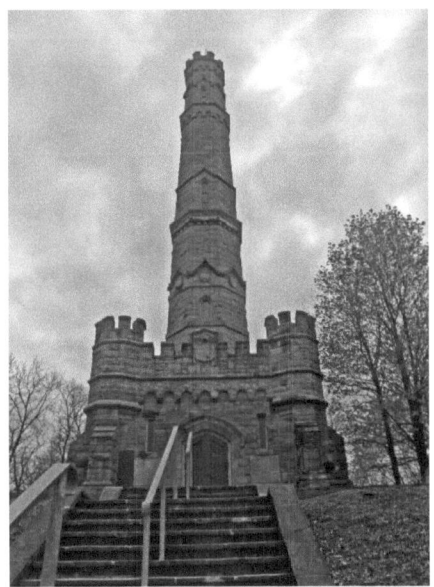

Battlefield Monument stands 100 feet tall and commemorates a century of peace between the British and the Americans.

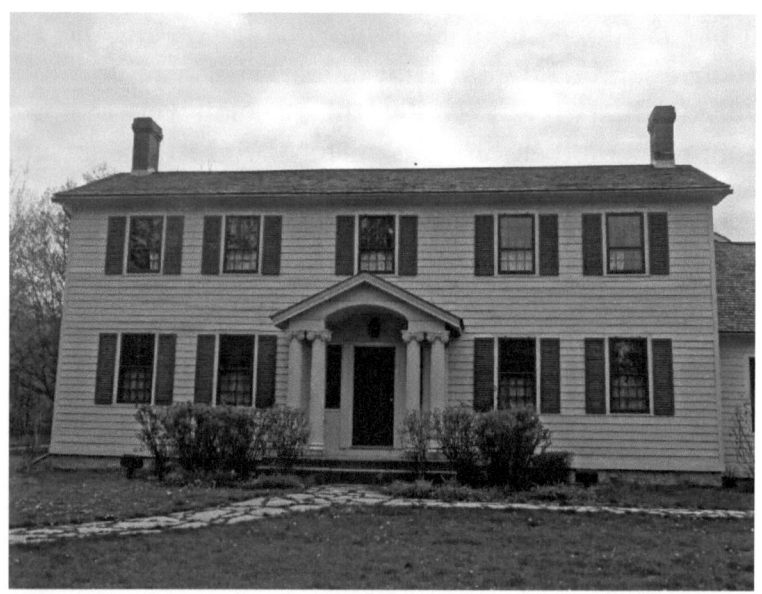

The Nash-Jackson House was originally located at the northeast corner of King Street East and Nash Road in Hamilton. The house was built in 1818 in the Georgian style. The house was moved to Stoney Creek Battlefield Park in 1999.

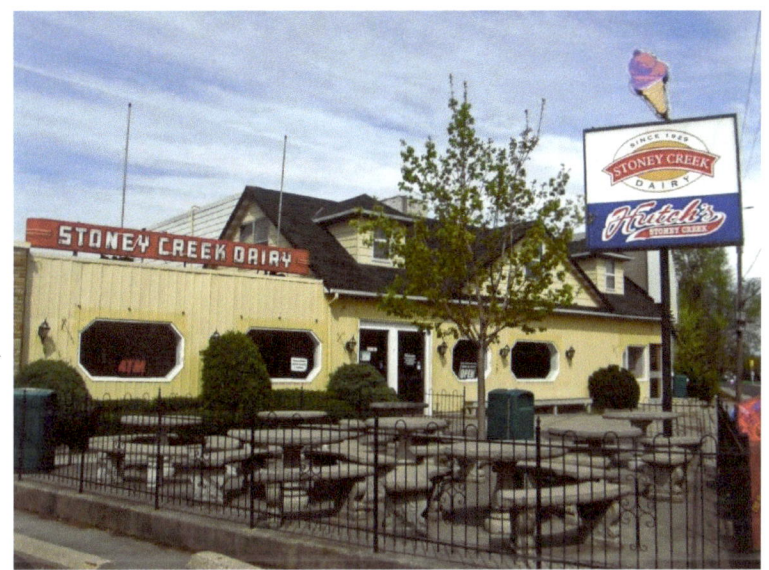

The Stoney Creek Dairy Bar, 135 King Street East, opened in 1941 to serve frozen treats. It closed in 2012.

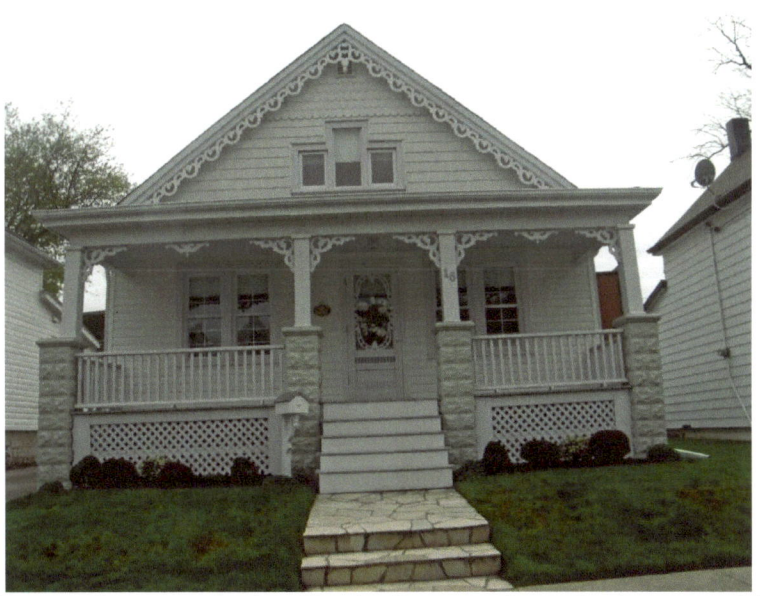

16 Jones Street – Gothic Revival, verge board trim on gable, Palladian window

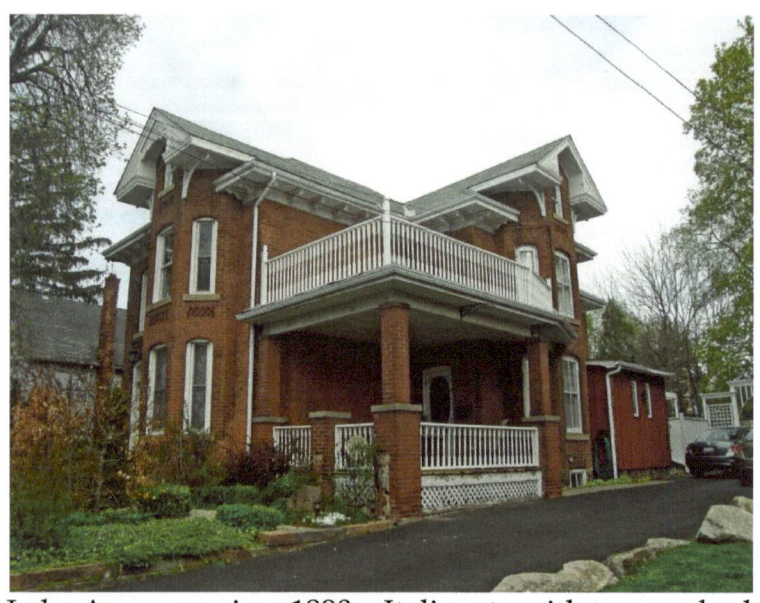

12 Lake Avenue – circa 1890 – Italianate with two-and-a-half storey tower-like bays with cornice return on gables, cornice brackets, verandah on each storey - Former Methodist Parsonage

42 Lake Avenue – Roubos Greenhouses (garden plants) – Italianate with steeply pitched hip roof, two two-and-a-half storey tower-like bays with cornice return on gables, corner quoins, pediment above doorway

Seaforth, Ontario – My Top 6 Picks

Seaforth is a southern Ontario community in Huron County. Originally known as *Four Corners* and *Steene's Corners* after an early settler, much of the area of what is now Seaforth was acquired by brothers Christopher and George Sparling in anticipation of the construction of the Buffalo, Brantford and Goderich Railway. Developer James Patton of Barrie purchased the land and laid out a town site in 1855.

Seaforth's Main Street is a Provincially Designated Heritage Conservation District, and architectural critics consider it to be one of the finest late 19th century streetscapes remaining in the Province.

A post office was established in Seaforth in 1859. In September 1876, at two o'clock in the morning, a fire broke out in Mrs. Griffith's Candy and Grocery store raging through Main Street destroying 12 acres of the business section. The town rebounded and Main Street was rebuilt with the brick and block structures which we see today, more than a century later. This architectural composition of two storey brick buildings is unique in its uniformity of scale and character. Through grants and local support, property owners have been encouraged to restore and preserve the architectural characteristics of their buildings so that this valuable resource may continue to be a reminder of Seaforth's history. The street is lined with uniquely homogeneous buildings and you will always know the time from one of the most lavish clocks of its day.

In 2001, Seaforth was amalgamated with Brussels, Grey Township, McKillop Township and Tuckersmith Township to form the Municipality of Huron East.

#143 – gable roof, two-storey bay window

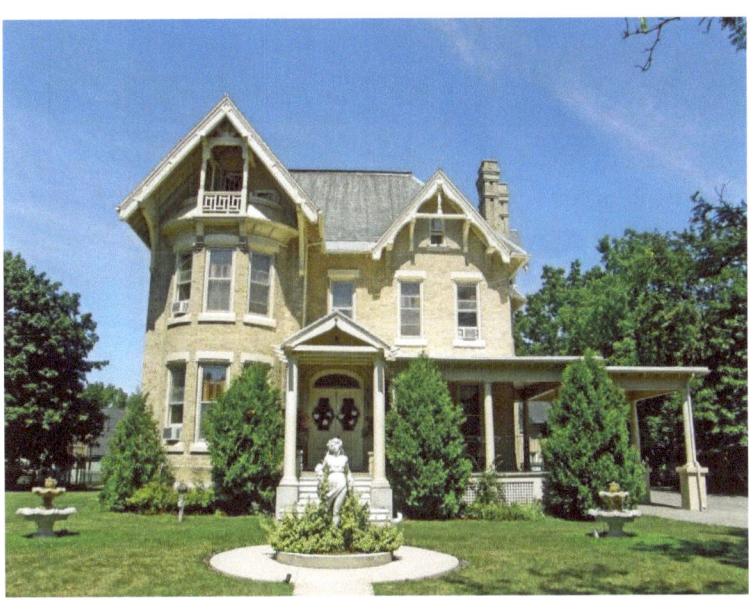
Two-storey tower-like bay with small balcony in gable

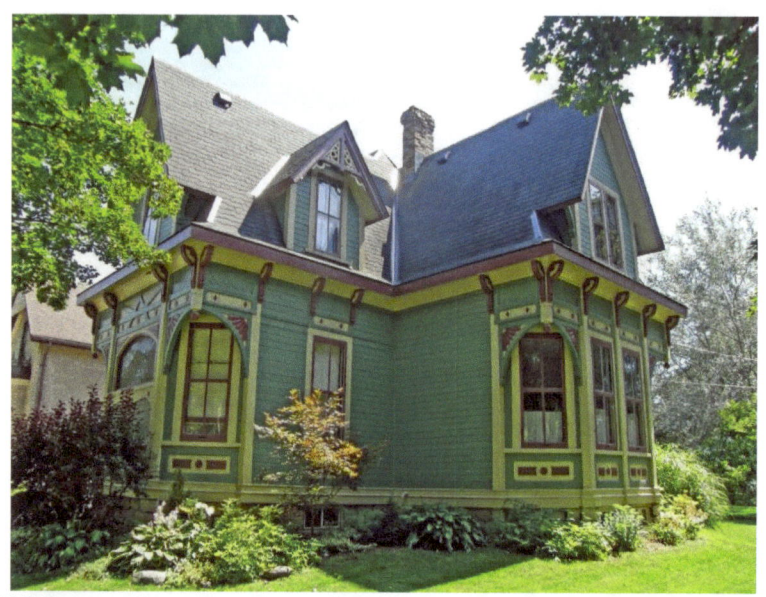

123 James Street – Carnohan House - The one-and-a-half-storey frame house was constructed in 1873. It is a good representation of late Victorian architecture. It has a cross-gabled roof, one-over-one and two-over-two, double hung, sash windows, dormer windows, and decorative wooden window surrounds and detailing.

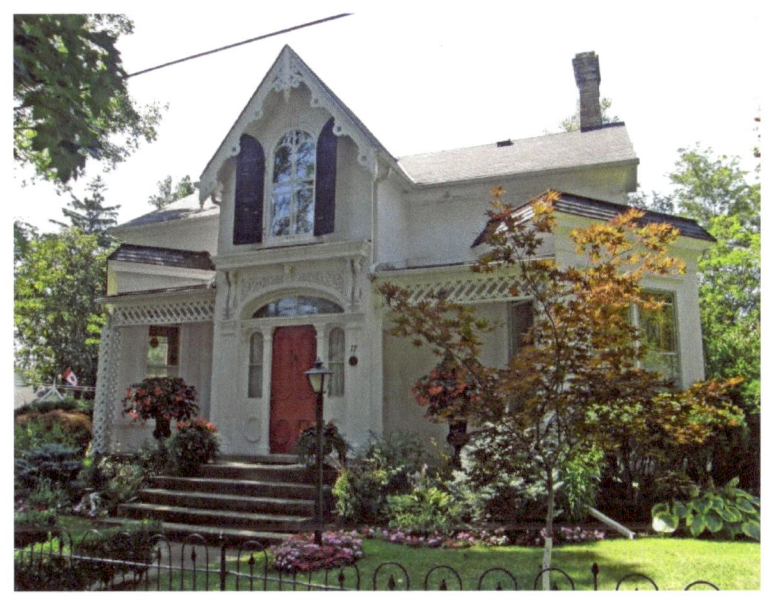

#17 – Gothic Revival – verge board trim on gable

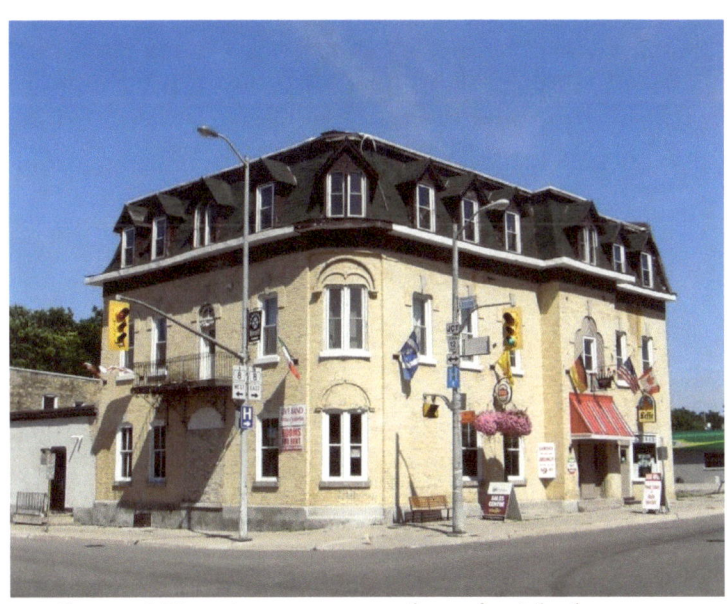

Second Empire – mansard roof with dormers

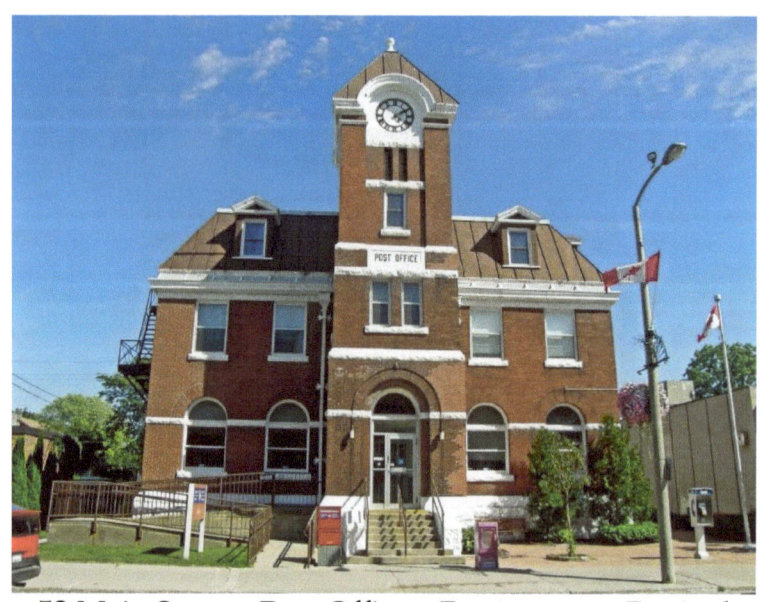

52 Main Street - Post Office – Romanesque Revival architecture with square center clock tower and round-headed windows. It was built from 1911-1913. There are dormers in the rooftop.

Aberfoyle and Morriston, Ontario – Top 6 Picks

Puslinch is a township in south-central Ontario in Wellington County south of Guelph. The area is rich in natural gas resources. About half of the township is forested, and a conservation area lies to the southwest. Near the western edge of the township, just outside of Cambridge, Ontario is Puslinch Lake, the largest kettle lake in North America. A kettle lake is a shallow, sediment-filled body of water formed by retreating glaciers or draining floodwaters.

The township includes the communities of **Aberfoyle**, Aikensville, Arkell, Badenoch, Barbers Beach, Corwhin, Crieff, Killean, Little Lake, Morriston and Puslinch.

Aberfoyle is the administrative center for Puslinch Township and the municipality's administrative offices and fire station are located here. Aberfoyle is located at the headwaters of Mill Creek, about ten kilometers south of Guelph. Aberfoyle was first settled in the 1840s and is named for Aberfoyle, Scotland. It is famous for its spring water.

Morriston is located in Puslinch Township at Highway 6 and County Road 36, one kilometre south of Highway 401, and sixteen kilometres southeast of Guelph. In 1847 Mr. R. B. Morriston opened a store in one end of his blacksmith shop and two years later built a store on the east side of the road.

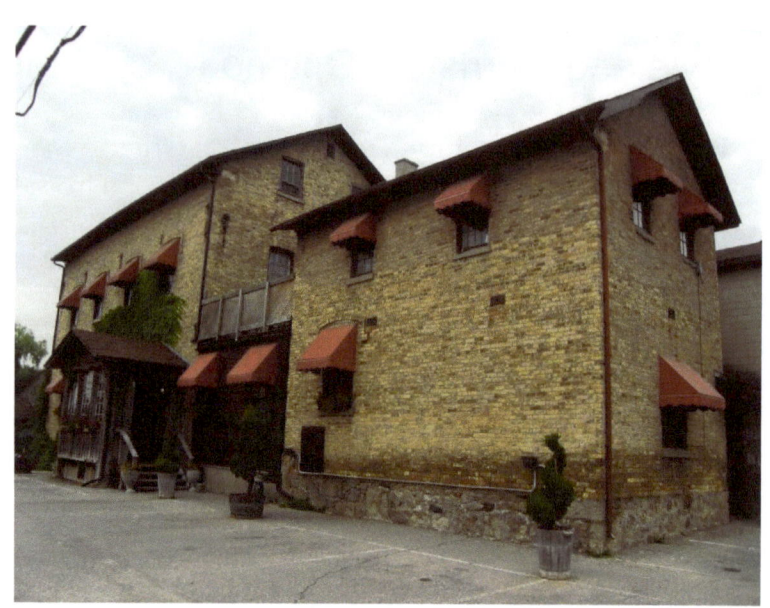

Aberfoyle Mill

Gothic Revival – cobblestone – cornice return on end gable – Aberfoyle

Gothic Revival - cobblestone architecture - Morriston

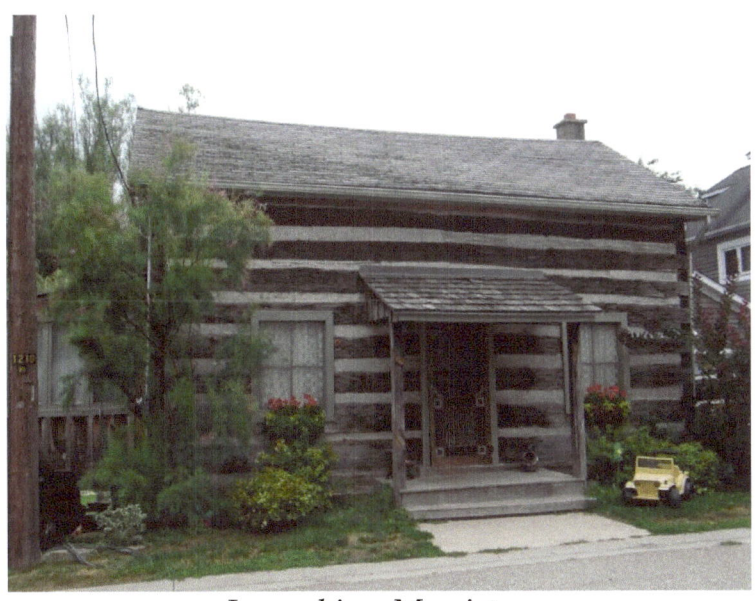

Log cabin – Morriston

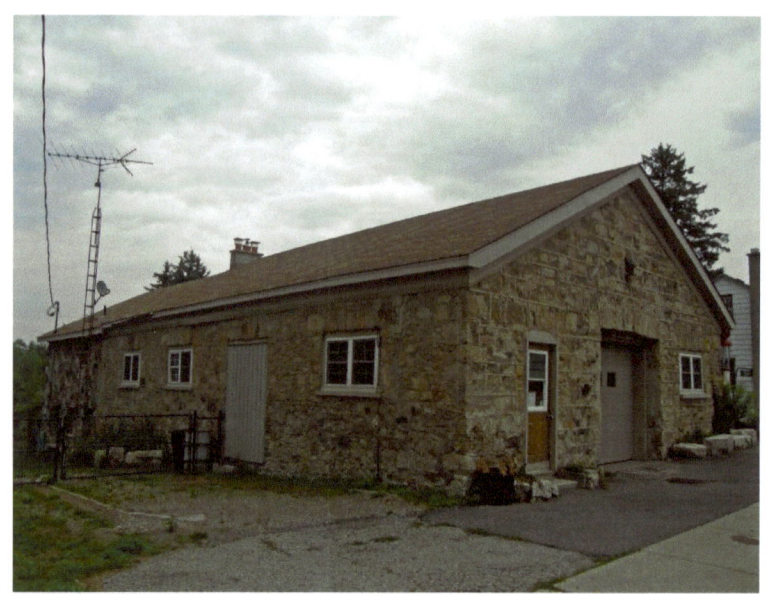

Puslinch Heritage Building – Gothic – cobblestone – Morriston

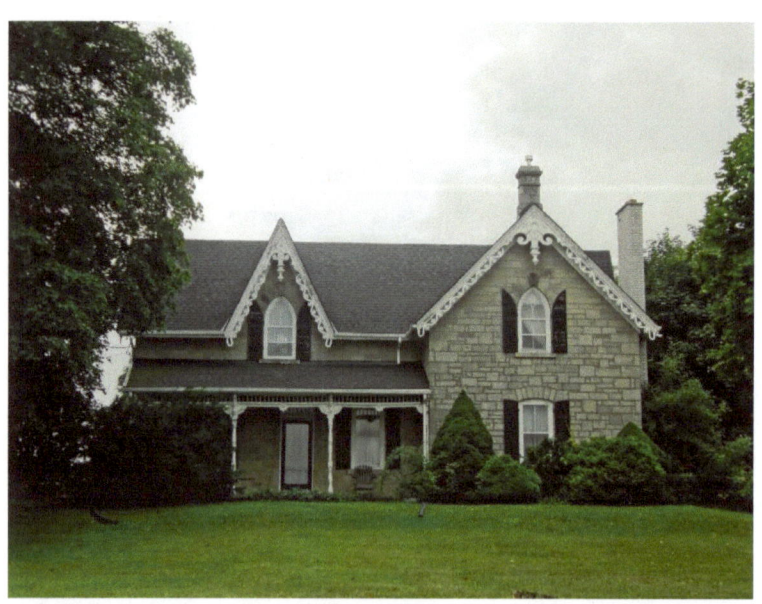

Gothic Revival – verge board trim on gables with finials – Morriston

Eden Mills, Eramosa and Everton, Ontario – My Top 7 Picks

Eden Mills was established in 1842 with the construction of the first of three mills and called Kribbs Mill. The mills used water power generated by the Eramosa River, which splits into two branches at the village then flows on to join the Speed River in Guelph, and finally to the Grand, the great Canadian Heritage River. When Adam Argo bought the mill he changed the name to Eden Mills, the name for the post office in 1851 with Mr. Argo as the postmaster. In the early days Eden Mills had a hotel, a flour mill, a wagon maker, blacksmith, general store, shoe store, cooper shop and a daily stage. The first church was of the Congregation Faith. During the nineteenth and early part of the twentieth century Eden Mills grew into an important center of commerce. In addition to its three mills, it boasted an imposing three-storey general store, a hotel (both still standing), post office, smithy, electric railway station, gas station and coffee shop.

Eramosa is located at the crossroads of Highway 124 and Wellington Road 29 east of Guelph.

Guelph/Eramosa is a township in Wellington County in mid-western Ontario. It partly encircles the city of Guelph from northeast to south southwest of the city.

Rockwood is the main community in the township. Rockwood is located on Highway 7 between Acton and Guelph. The Eramosa River runs through the center of the village and the river was the source of power for several mills that were built for the original settlement. Limestone was also extracted from the area. The Rockwood Conservation Area is used for swimming, hiking, canoeing, picnicking and camping. The township includes Everton and several more small communities.

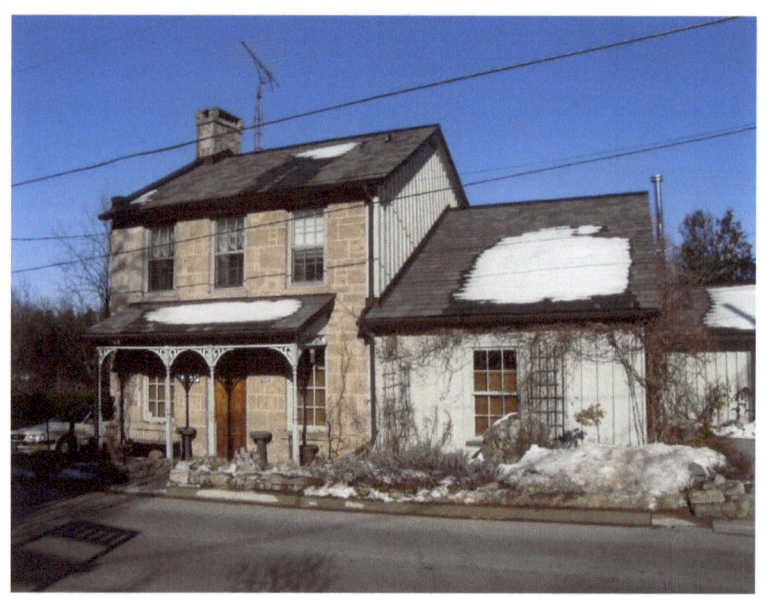

Stone building – Gothic Revival – Eden Mills

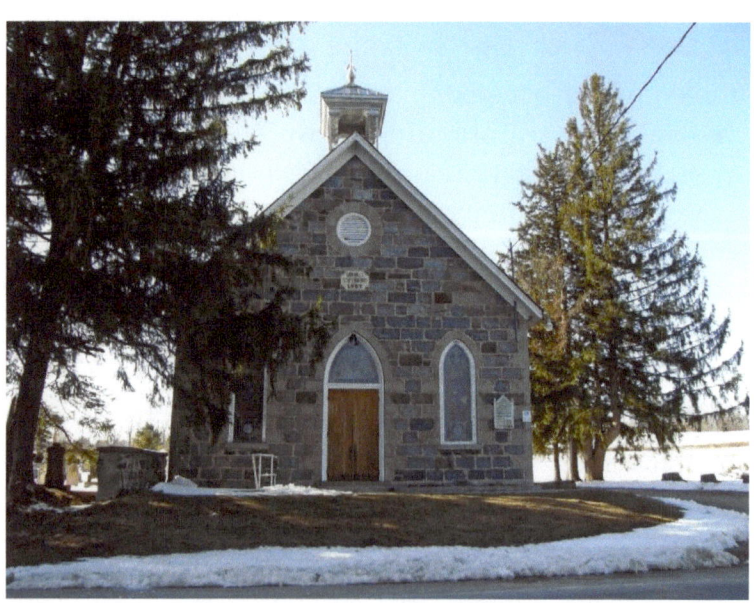

Eden Mills Presbyterian Church – 1887 – Gothic Revival – Eden Mills

Eden Mills, Eramosa and Everton, Ontario – My Top 7 Picks

Eden Mills was established in 1842 with the construction of the first of three mills and called Kribbs Mill. The mills used water power generated by the Eramosa River, which splits into two branches at the village then flows on to join the Speed River in Guelph, and finally to the Grand, the great Canadian Heritage River. When Adam Argo bought the mill he changed the name to Eden Mills, the name for the post office in 1851 with Mr. Argo as the postmaster. In the early days Eden Mills had a hotel, a flour mill, a wagon maker, blacksmith, general store, shoe store, cooper shop and a daily stage. The first church was of the Congregation Faith. During the nineteenth and early part of the twentieth century Eden Mills grew into an important center of commerce. In addition to its three mills, it boasted an imposing three-storey general store, a hotel (both still standing), post office, smithy, electric railway station, gas station and coffee shop.

Eramosa is located at the crossroads of Highway 124 and Wellington Road 29 east of Guelph.

Guelph/Eramosa is a township in Wellington County in mid-western Ontario. It partly encircles the city of Guelph from northeast to south southwest of the city.

Rockwood is the main community in the township. Rockwood is located on Highway 7 between Acton and Guelph. The Eramosa River runs through the center of the village and the river was the source of power for several mills that were built for the original settlement. Limestone was also extracted from the area. The Rockwood Conservation Area is used for swimming, hiking, canoeing, picnicking and camping. The township includes Everton and several more small communities.

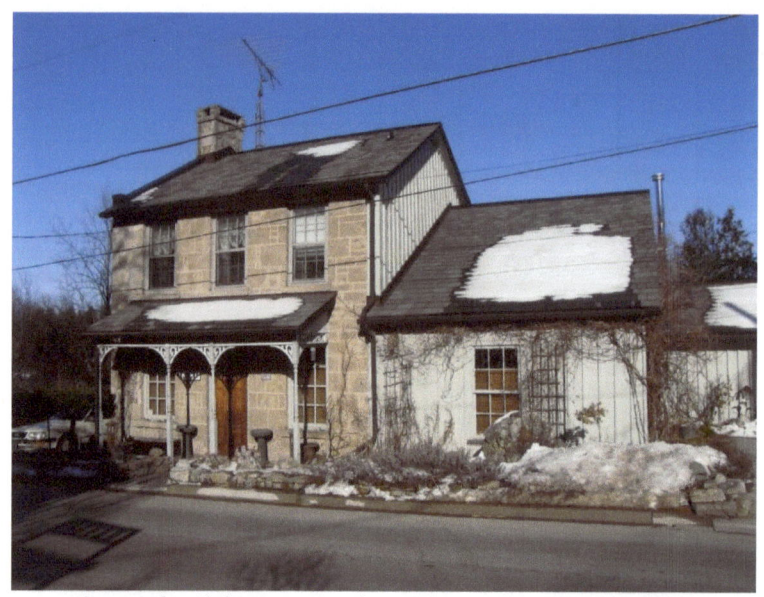

Stone building – Gothic Revival – Eden Mills

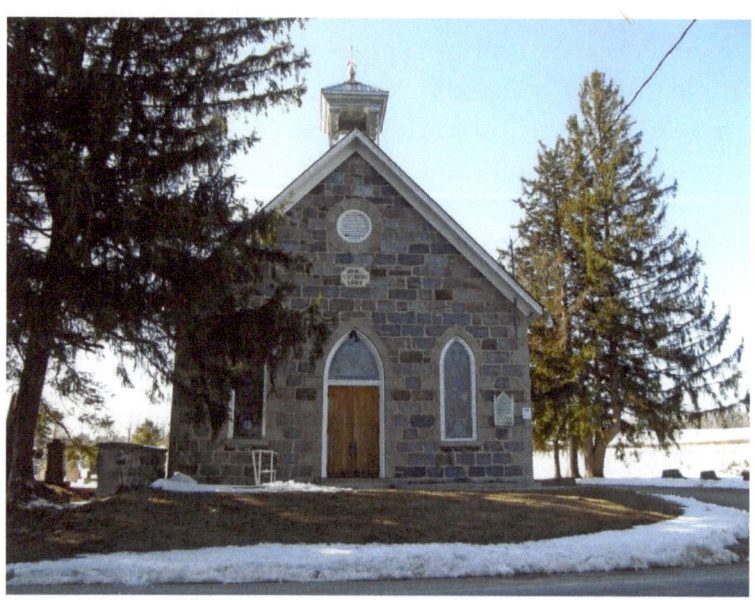

Eden Mills Presbyterian Church – 1887 – Gothic Revival – Eden Mills

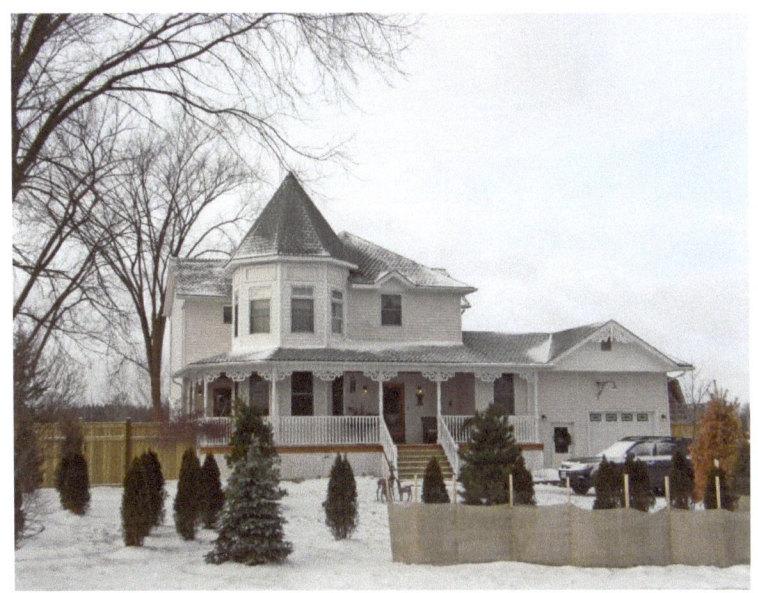

Queen Anne style – turret - Eramosa

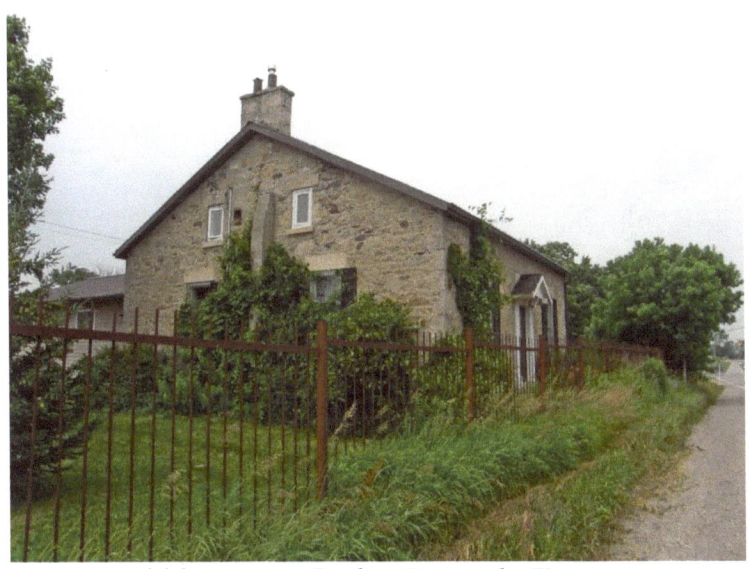

Cobblestone – Gothic Revival - Eramosa

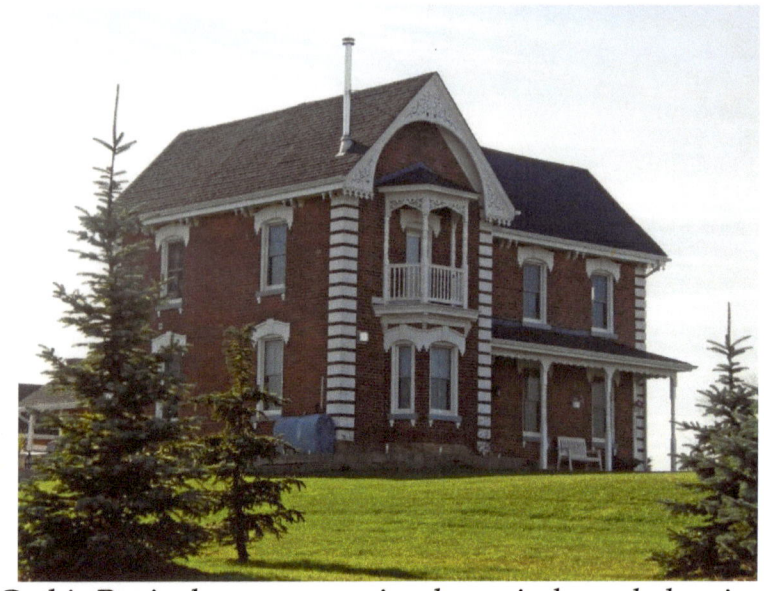

Gothic Revival – corner quoins, bay windows, balconies - Eramosa

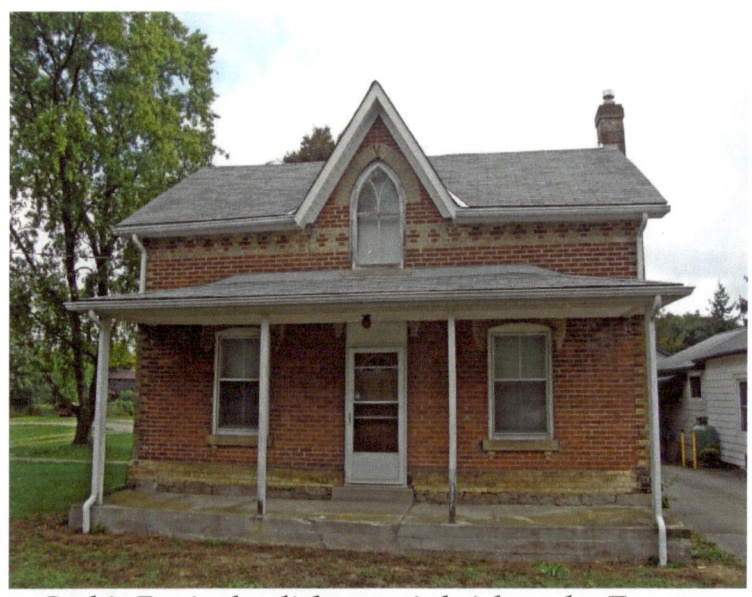

Gothic Revival – dichromatic brickwork - Everton

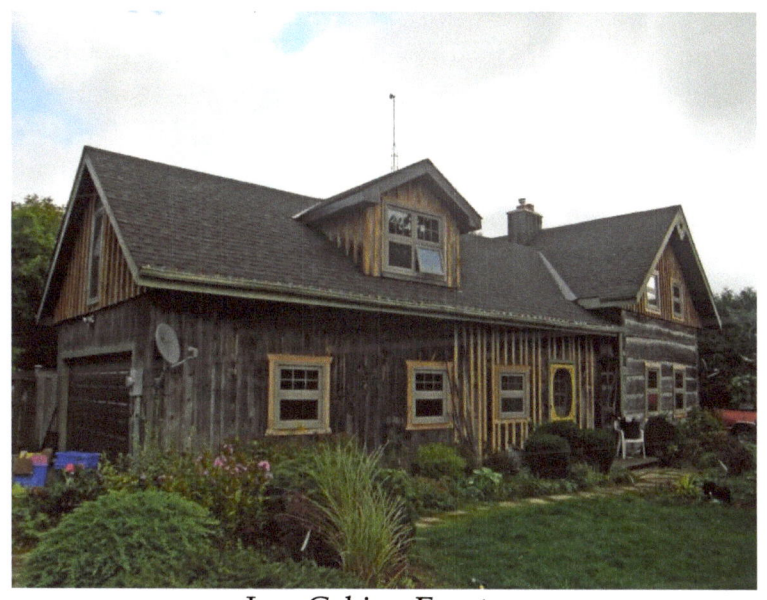

Log Cabin - Everton

Fergus, Ontario – My Top 7 Picks

Fergus is the largest community in Centre Wellington, a township within Wellington County. It lies on the Grand River about 25 kilometers north of Guelph.

The first settlers to this area were freed slaves who formed what was known as the Pierpoint Settlement, named after their leader, Richard Pierpoint. Along with half a dozen other men, Pierpoint was granted land in Garafraxa Township in what is now Fergus.

Adam Fergusson visited Canada in 1831 to investigate emigration for the Highland Society of Scotland. In 1833 in partnership with a fellow Scot, James Webster, they purchased over 7,000 acres of uncleared land in Nichol Township. Attracted by the abundant water power, they laid out the town of Fergus. Webster took up residence there and supervised the settlement's early development. The first house was built in 1833, then a hotel, a saw mill, grist mill, church and school.

They established a vibrant economy using the waterfalls on the Grand River as power for local industry. The Scots built solid stone houses, factories and other buildings which have characterized Fergus to this day. Many of the houses and factories built by these early settlers are still in use today.

Originally Fergus was known as Little Falls, because of the scenic waterfalls downtown between the Public Library and the Fergus Market.

St. Andrew Street runs parallel to the Grand River on the north side and is the heart of downtown. On the south side of the river is Queen Street where the newly renovated Fergus Market is located.

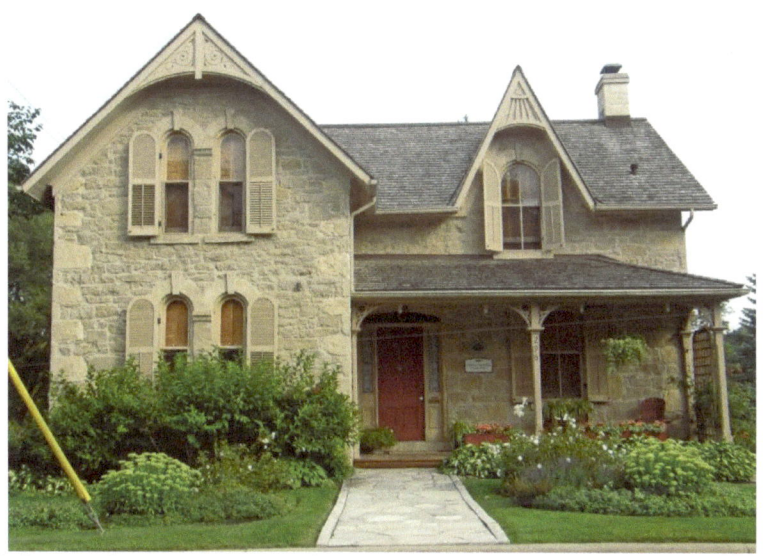

296 St. Andrew Street – Thomas Cumming, Carriage Maker – c. 1891 - Gothic Revival, verge board trim on gables, semi-circular window voussoirs with keystones, corner quoining

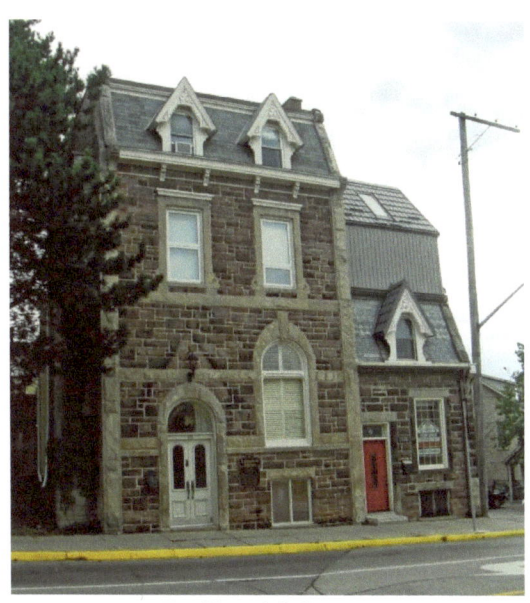

St. David Street

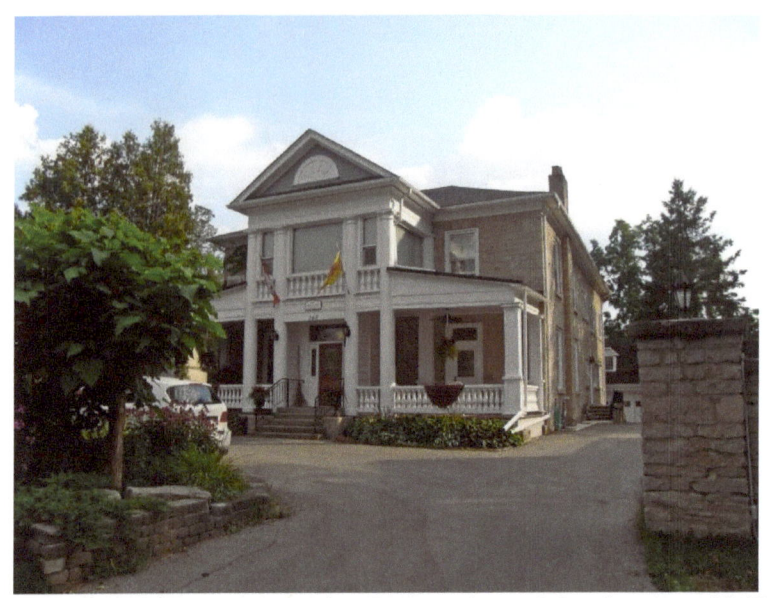

265 St. David Street North - James Argo Merchant c. 1867 - Neocolonial style - hipped roof, two-storey-tall Doric porch pillars topped with pediment with decorated tympanum

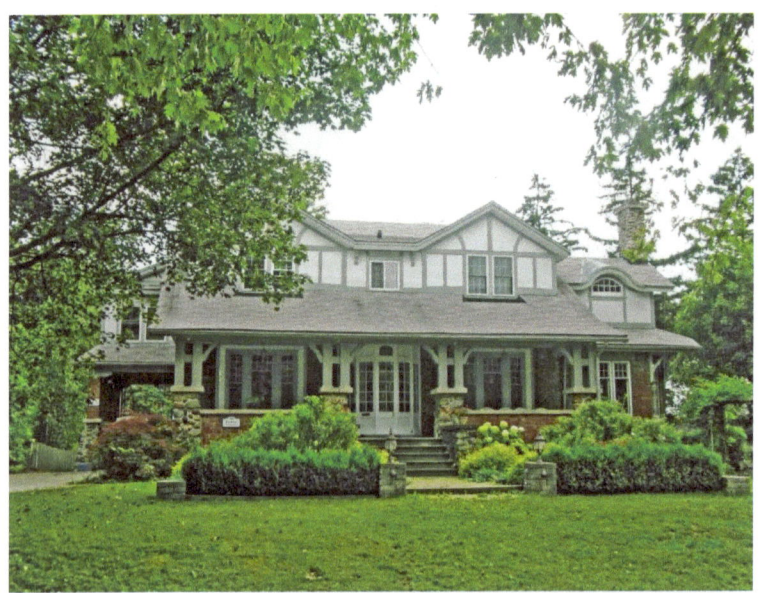

St. David Street - W. G. Beatty, Foundry – c. 1912 – Tudor style

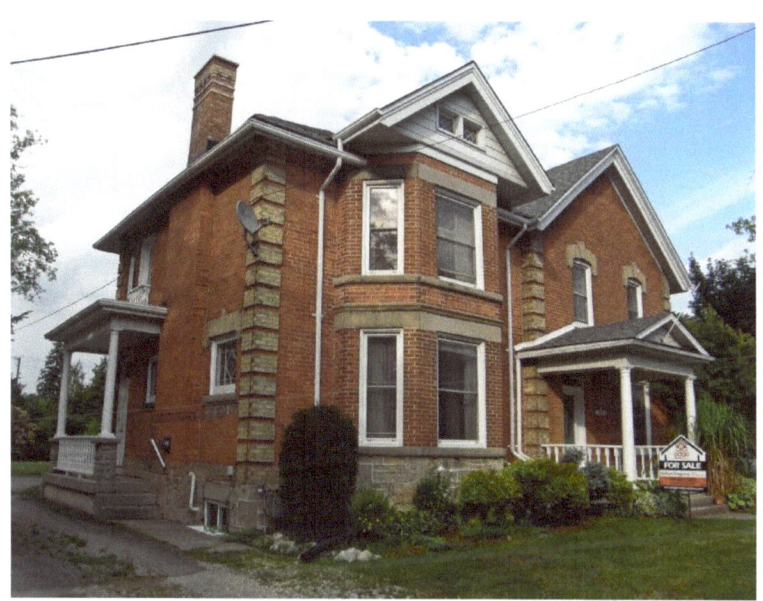

#250 St. David Street – Edwardian/Gothic – corner quoins, arched window voussoirs with keystones, pediment

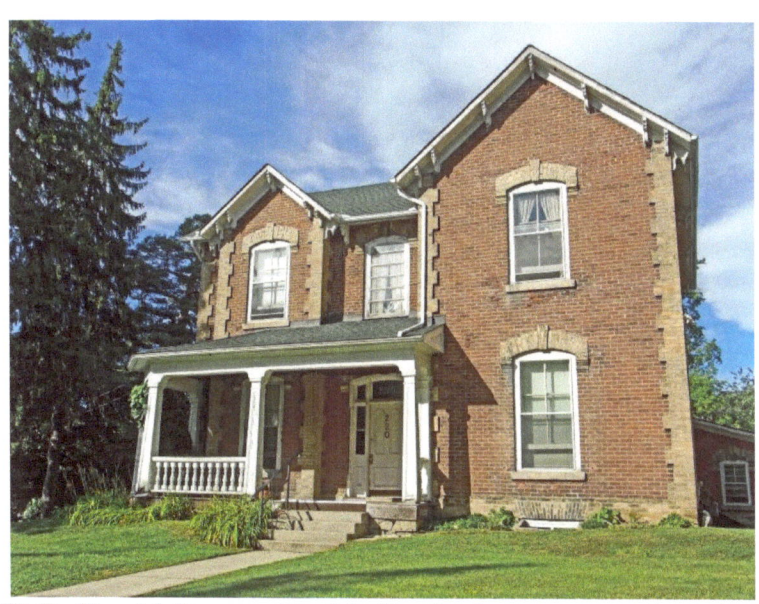

220 St. David Street – Gothic Revival, corner quoins, single cornice brackets

www.ingramcontent.com/pod-product-compliance
Lightning Source LLC
Chambersburg PA
CBHW041103180526
45172CB00001B/85